IMAGES
of America

CARPINTERIA

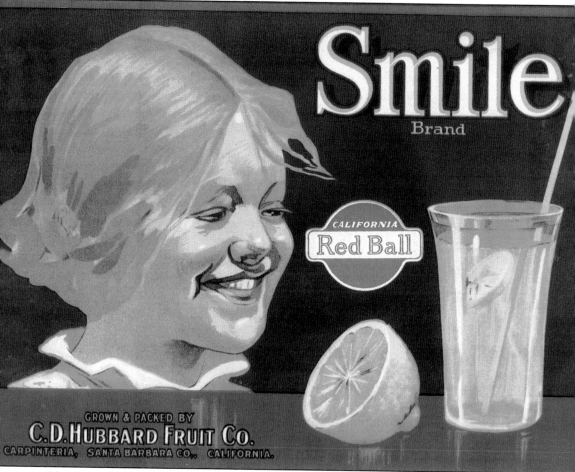

This young lady knew what to do with lemons—make lemonade. And C. D. Hubbard knew what to do with his crated lemons—put labels on them that featured vibrant, smiling youngsters. (Courtesy Jim Campos.)

ON THE COVER: Schools for Carpinteria's children are mentioned as early as 1858 in the memoirs of the pioneers. This photograph is of the Carpinteria School in 1894. (Courtesy Carpinteria Valley Museum of History.)

IMAGES
of America

CARPINTERIA

Jim Campos, Dave Moore,
Tom Moore, Lou Panizzon,
and the Carpinteria Valley Museum of History

ARCADIA
PUBLISHING

Published by Arcadia Publishing
Charleston, South Carolina

Printed in the United States of America

Library of Congress Catalog Card Number: 2007921318

For all general information contact Arcadia Publishing at:
Telephone 843-853-2070
Fax 843-853-0044
E-mail sales@arcadiapublishing.com
For customer service and orders:
Toll-Free 1-888-313-2665

Visit us on the Internet at www.arcadiapublishing.com

*To our wives and youngsters, who've provided us with more
"boys will be boys" latitude during this adventure than any
of us had any right to expect, and to Carpinteria, the coastal
paradise that takes our breath away on a daily basis.*

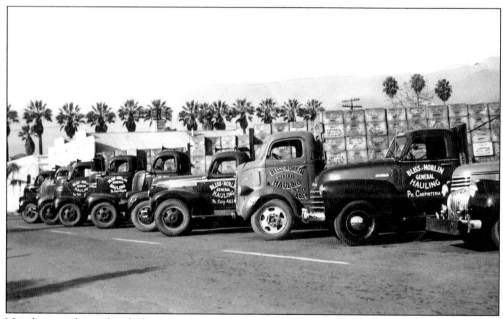

Need something hauled? Carpinteria's trucking fleet stood at the ready. (Courtesy
Rich Medel.)

CONTENTS

ACKNOWLEDGMENTS

Heartfelt thanks to Herman Zittel, Louise Moore, and Lawrence Bailard for their tireless efforts on behalf of this project. Herman spent hours helping the authors navigate the Carpinteria Valley Historical Society's Museum of History's remarkable collection of photographs with nary a complaint. Louise cajoled, coordinated, and computerized a well-intentioned collection of narratives and photographs from hodgepodge to history. And Lawrence provided invaluable insights on Carpinteria history, as well as unearthing a remarkable array of terrific photographs of the valley.

Special thanks are also due David Griggs, director/curator of the Carpinteria Valley Museum of History; Susie Panizzon; Patty Manuras; and Terry Walker for cheerfully repairing our garbled grammar, imperfect punctuation, and historical inaccuracies.

We looked at approximately 1,250 photographs of the valley, and were we able, we would have used them all. Unfortunately, the publisher's template for the *Images of America* series limited us to a maximum of 214 photographs.

The kindness extended to us during the orchestrating of this project was remarkable, even by Carpinteria standards. If we overlooked anyone in what we hope is a comprehensive listing, please accept our apologies.

Thanks go to Raul Angulo, Ed Arellano, Andy Bailard, Joan Rock Bailard, Rosemary Zea Bauer, Vera Bensen, Jane Bianchin, George Bliss, Jeff Boyd, Jonathan Brown, Bill Caldwell, Jayne Caldwell, Sal and Delia Campos, Carpinteria-Summerland Fire District, Christina Castellanos, Cate School Archives, Bill Catlin, Lawrence Cervantes, City of Carpinteria, *Coastal View News*, Barnaby Conrad, Joan Cota (Joel Conway Historical Collection), Nan Deal, Tom DeAlba, Mike and Cheryl Dehnke, Jennifer Powell DeSandre, Robert Franco, John Fritsche, John Frontado, Kara Glenister family, Jesus and Lucy Gonzales, David and Anita Goodfield, Llewellyn Goodfield, Dale Goodmanson, Angelo and Marie Granaroli, Lee Hammock, George Holsten, Bill Horton, William Franklin Horton, Bruce and Peggy Humphrey, Ernie Johnson, Sey Kinsell, Pete Langlo, Roxie Grant Lapidus, Pat Latham, Van Latham, Delores Macias, John Macias, Steve Malone, Rosie Martinez, John McCafferty, Jenifer McCurry, Ruth McIntyre family, Rich Medel, Bonnie Milne, Matt Moore, Murray's Sports, Nola Treloar Nicklin, Larry Nimmer, Peggy Oki, Roberto "Olly" Olivas, Tom and Mary Ota, Marty Panizzon, Nan Treloar Panizzon, Andy Powell, Jack Risdon, Claire Roberts, Jerry Roberts (Arcadia Publishing), Jim Rockwell, John Rodriguez, Ernie Sanchez, Domingo Saragosa, Russell Silva, Patty Sim, Harold and Nancy Smith, Georgia Stockton, Jerome Summerlin, Yvette Torres, Doug Treloar, Winfield Van der Mark, Yoze Van Wingerden, Joe and Alice Vasquez, Tyson Willson, Willie Wood, and Betty Zittel.

INTRODUCTION

Carpinteria is a small Midwestern town located on the Southern California coast. While other Southern California hamlets were moving, shaking, and being upwardly mobile, Carpinterians were digging in. Time spent in Carpinteria is measured in generations, not decades. What could possibly be more Midwestern?

The intimacy level in Carpinteria borders on the familial. Adolescent rites of passage are practiced locally under severe duress. For example, how can you learn to smoke with any real flair when every corner you turn is patrolled by your uncle, or your grandmother, or your little sister's gossipy best friend? It is a tough row to hoe, and every Carpinteria teenager knows it. This is the essence of relational Carpinteria, and the locals could not be happier about it.

Carpinterians, almost without exception, characterize the coastal plain they live on as a valley. Forgive them, we suspect it is a subconscious effort to isolate their little slice of heaven from the confusion and rigors of a much less fortunate world.

It was the Chumash Indians' ancestors, nearly 10,000 years ago, who first claimed the Carpinteria Valley as their home. One would suspect that they landed here for the same reasons that most Carpinterians do—a temperate climate, a spectacular environment, and the availability of all the ingredients fundamental to sustaining life.

The Chumash were hunters, gatherers, and fishermen. They had few rivals in boat building and basket making. It was admiration for their boats, after all, that prompted Spanish explorers to name the local Chumash settlement of Mishopshno *La Carpinteria*—the carpenter's shop. Their baskets were so tightly woven that they could hold water.

Natural abundance, and the Chumash's ability to maximize it, appears to have trumped any interest the Chumash might have had in agrarian pursuits. But the folks who followed in their footsteps established an agricultural tradition that has done nothing but pick up speed. An abbreviated listing of the ingredients of Carpinteria's cornucopia would include walnuts, strawberries, lima beans, oranges, avocados, kiwis, cherimoyas, grapes, pampas grass, flowers, lettuce, and lemons.

Many of Carpinteria's early entrepreneurial endeavors were uncommonly creative. Mineral soap mining, turtle farming, ostrich ranching, cat farming, salt refining, and asphalt mining all gained at least temporary traction in the valley's early years. If you could imagine it and you were willing to work hard, you could probably get it off the ground in Carpinteria.

The automobile also played a significant role in the sculpting of Carpinteria. For decades the Coast Highway wound through what is now downtown Carpinteria, almost certainly influencing the location and type of businesses that sprouted on today's Linden and Carpinteria Avenues.

The strategic placement of the "World's Safest Beach" slogan on the tallest structures near the Coast Highway and Linden Avenue was intended to turn travelers toward Carpinteria's greatest tourist attraction, the beach. And, in the turning, the city fathers also firmed up a business district that extended well down Linden Avenue, taking advantage of a destination for vacationers that was so hypnotic that the "World's Safest Beach" attracted hundreds of thousands of visitors yearly.

But as perceptive as Carpinteria's forefathers were, it is difficult to believe that even they had any real sense of how big a small town could get without getting big.

Numerous disasters—including the 1969 oil spill, which drew national attention to Carpinteria and was the genesis of the modern-day environmental movement—have visited Carpinteria over the years. But the valley's strong sense of family has always directed and empowered both containment and renewal. Social issues, over time, have generally been attended to in similar fashion. Carpinterians, though not perfect, have proved to be resilient, thoughtful, and fair-minded over the long haul.

The 101 freeway came to Carpinteria in the 1960s. The dirt from various freeway excavations ultimately covered the Thunderbowl, which had once featured a circular speedway filled with jalopies, motorcycles, and midget racers.

Carpinteria was incorporated in 1965—not an altogether stressless undertaking, although many of the folks who so adamantly encouraged or discouraged this transition have long forgotten what all the ruckus was about.

Carpinterians have continued to demonstrate their generosity by supporting the building of a Boys and Girls Club, Girls, Inc., the Carpinteria Lions Park and community building, a community pool, a new football stadium (the original Memorial Field was one of the city's first philanthropic efforts), the Carpinteria Valley Historical Museum, and an arts center, which will be built on a site that was purchased with community donations.

The preservation of the Bluffs, the establishment of the Carpinteria Salt Marsh Nature Park, creek preservation, and the ongoing Seal Watch Project make it abundantly clear that Carpinterians are also dedicated to maintaining their spectacular natural surroundings.

Carpinterians, while enthusiastically embracing their future, never stray too far from the images in their rearview mirrors, recognizing as they do that the place, the events, and the people in their past have, in the most fundamental way, escorted them to where they stand today.

The 1912 Chamber of Commerce Annual stated that "Carpinteria Has: a location at the heart of Carpinteria Valley, which is the Eden Spot of Santa Barbara County, the American Italy. A more even and delightful climate than Santa Barbara, producing roses and strawberries everyday of the year. Good churches, schools and social conditions. A wide awake Chamber of Commerce. A strong bank and a live newspaper. The most attractive and safest beach in Southern California. An environment of rich, inexhaustible, well watered ranch lands, extending from Montecito to Casitas Pass, from the coast range to the ocean, which produce, in lavish abundance, walnuts, lemons, small fruits, and almost everything grown in a semi-tropic clime. The most magnificent mountain and ocean scenery. The above are cold facts. Write the secretary of the Carpinteria Chamber of Commerce."

Remarkably, not much has changed. This "if it ain't broke', don't fix it" mentality is, arguably, the ultimate expression of the devotion Carpinterians have for the coastal plain they call home.

One

FIRST STEPS
IN THE VALLEY

The author of the initial effort to document Carpinteria's history, Georgia Stockton, called the valley "a veritable Eden awaiting the coming of the first man." And so it must have been for the indigenous people who lived here for thousands of years before the coming of the Spaniards. The Spanish explorers, coming by land and sea, found the Chumash people, who lacked little for subsistence. The Spanish period added ranchos with livestock to the landscape and dotted the valley with adobe homes. Around 1850, American pioneers, most exploring their way down the coast from the Northern California goldfields, found opportunity in the little valley by the sea.

The first business venture by the Anglo-Americans that dramatically increased the valley's population was the asphalt mines. But Carpinteria, first and foremost, has always been about its fertile valley and its capacity for agriculture. Families that settled in the valley did so as farmers. After a period of experimentation with a variety of crops, the farmers turned agriculture into big business. Carpinteria's natural beauty of mountains, streams, a coastal plain, and its calm oceanfront with fine, white sands also made it a popular tourist attraction. Early residents took advantage by building up the business section along Linden Avenue near the train depot and by establishing resorts like the Shepard's Inn, which was to become a world-famous destination for travelers.

Needing few outside resources in the garden spot that is Carpinteria, growth was slow in urban terms. But because farming was strong commercially, it afforded valley residents the economic means to establish the creature comforts of bigger communities. Nestled between the larger cities of Ventura and Santa Barbara, it was not long before Carpinteria left its frontier days for the modern era.

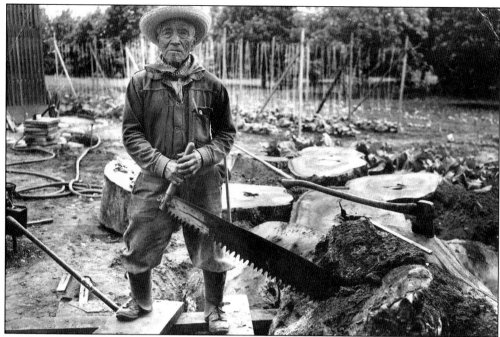

Pete Jimenez is shown clearing trees in this 1935 photograph. He claimed to be a descendant of a Spanish soldier who deserted the Portola expedition in 1769 and settled around the Carpinteria Valley with a Chumash wife. Another account says he was actually a descendant of a Filipino sailor who washed ashore from a shipwreck off Point Conception. "Old Pete" or "Manila Pete," as he was known in the valley, was the source of many Chumash stories and legends. (Courtesy Carpinteria Valley Museum of History.)

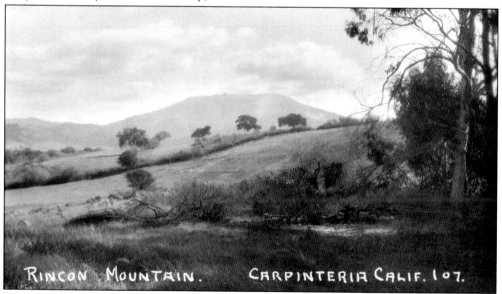

Rincon Mountain, shown in the background of this photograph, had great significance in the lore of the Chumash and factors into many of the stories handed down about them. The Spaniards in their time used the mountain as a lookout point and the dividing line, or corner, of the Santa Barbara Mission lands. (Courtesy Sey Kinsell.)

Bernarda Ruiz-Rodriguez, featured in the center of this photograph *c.* 1870, descended from the first Spanish soldiers who had been stationed at the Santa Barbara Presidio. There is evidence that Bernarda was a key figure in keeping the seizure of Alta California by the U.S. Army under Capt. John C. Fremont, a relatively bloodless affair. This made her a heroic figure to some and a traitor to others. Her sons, Juan José and Carlos, settled in the Carpinteria Valley. (Courtesy John Rodriguez.)

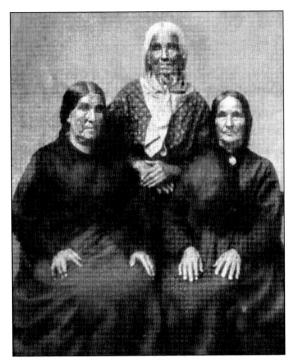

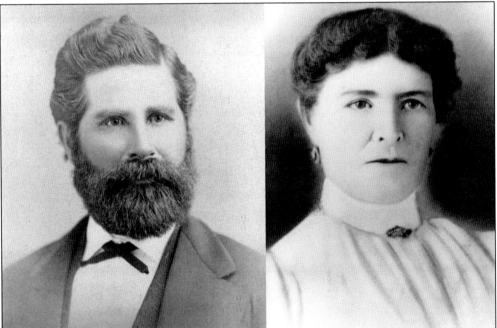

Juan José Rodriguez married Bibiana Breck, settling near Casitas Pass Road in 1861. Ethnic intermarriage between the Spanish-speaking people who lived in California after it fell to the United States—known to history as the Californios—and English-speaking Anglo pioneers was common in the Carpinteria Valley. The Rodriguez family line contains many well-known surnames from early pioneer families that include Cadwell, Kerr, Miller, and Smith. (Courtesy John Rodriguez.)

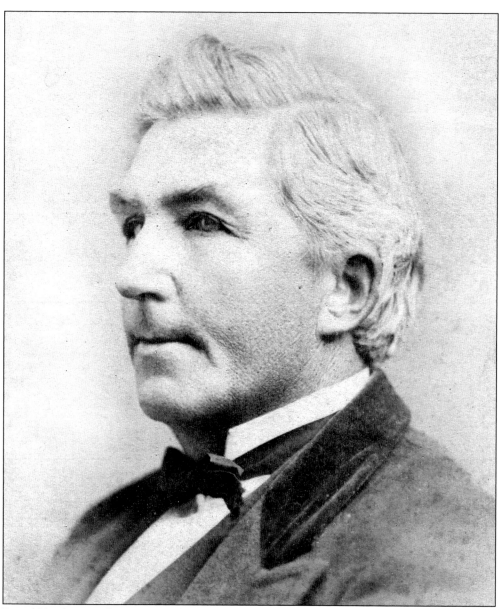

Russel Heath arrived in Santa Barbara County in 1853. He had an illustrious life in the region, serving as county sheriff, coroner, district attorney, and legislator. In 1858, he moved to the Carpinteria Valley. During the infamous lynching of Carpinteria resident Francisco Badillo—a suspected cattle rustler—and his son by a group of pioneer vigilantes led by John Nidever, it was Colonel Heath whom the Spanish-speaking population of Californios turned to for the administration of justice. The event caused so much tension between the Californios and the pioneers that the mayor of Santa Barbara and the district attorney—both Californios—resigned, leaving the county virtually without government. Heath's exciting frontier life also included a confrontation with California bad man Salomon Pico (perhaps the inspiration for the mythical Zorro), but it is as a Carpinteria farmer that he is best remembered in the valley. The ruins of his adobe home still stand in Heath Ranch Park as a Carpinteria monument, Historical Landmark No. 2–City of Carpinteria. (Courtesy Carpinteria Valley Museum of History.)

The adobe house was the preferred style of home for the Spanish Californios. This *c.* 1870 photograph may show the home of Carlos Rodriguez and Tomasa Hernandez-Rodriguez in Franklin Canyon, which was known for its Lamarque rosebush. (Courtesy Sey Kinsell.)

The home of Stephen and Sarah Olmstead was built in a sycamore split-log cabin style. It served as the center for the growing American population. Olmstead had come from the Northern California goldfields to settle in the valley in the 1860s. He bought 100 acres from the widow of Francisco Badillo, who had been lynched by vigilantes in 1859. The Californios thought he had bilked her out of her land and sought to lynch him, but Badillo's widow intervened on his behalf. (Courtesy Carpinteria Valley Museum of History.)

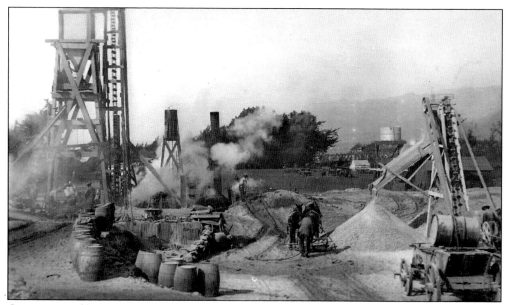

Carpinteria's first commercial industry was the surface-mining of asphalt beginning in 1875. Depending on the historical source, 200 to 600 men were lured to Carpinteria to work the mines for about a 50-year period. The workforce would dramatically affect the valley's population and business climate depending on the fortunes of the mines. (Courtesy Doug Treloar.)

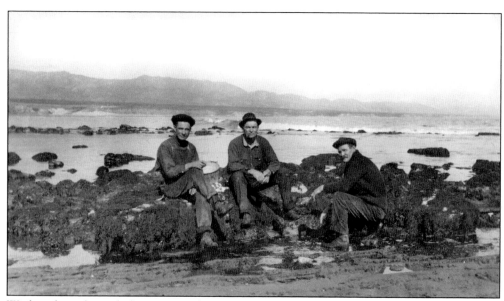

Workers from the asphalt mines are shown in this photograph digging for cockles around 1900. Shellfish was a staple food for the Chumash centuries before the arrival of the Spanish and the American pioneers. Carpinteria's ocean has long provided sustenance to residents and visitors alike. (Courtesy Doug Treloar.)

Hunting trips into the mountains were popular among Carpinteria residents who, prior to 1900, were not far removed from the wild frontier. Local lore tells of Carlos Rodriguez roping bears for sport, then tossing his lariat over branches and pulling the bears up the mighty oak trees in the valley. The Lambert and Smith family riders in this photograph, *c.* 1900, are literally loaded for bear. (Courtesy Harold Smith.)

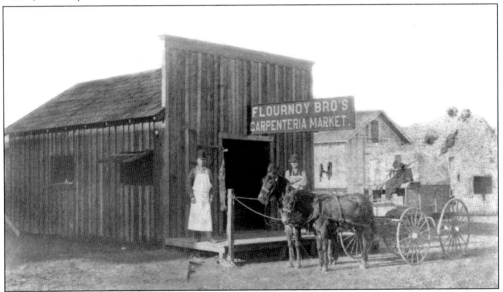

Living in Carpinteria during frontier times demanded that every household be self-sufficient, providing for its every need by utilizing livestock for meat, milk, butter, cream, and eggs and the orchards and gardens for a variety of fruits and vegetables. A trip into town to patronize a store like the Flournoy Market, shown here in 1879, was mainly for purchasing flour, salt, sugar, and the materials to sew clothing. (Courtesy Carpinteria Valley Museum of History.)

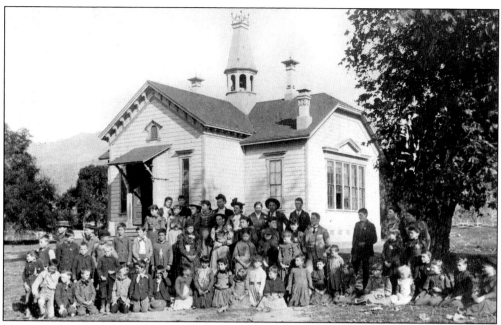

As early as 1858, schools are mentioned in the memoirs of the American pioneers who came to Carpinteria. This photograph is of the Carpinteria School in 1894. Photographs that survive of the Old School, as it came to be called, show two distinct buildings, which would indicate that a smaller Carpinteria School may have been razed to build a larger one. (Courtesy Carpinteria Valley Museum of History.)

The Franklin, Moore, and Thurmond families arrived in Carpinteria because of hardships endured in the South during the Civil War. In this c. 1890 photograph, Ariana Moore is seated on the left. Gideon Franklin is in the middle, flanked by the young Oglesby girls—Pearl (left) and Anabelle. Several historical accounts relate that the Southern families had a difficult time adjusting to a new way of life without a slave labor class but were taught to manage by their new neighbors in the valley. (Courtesy Carpinteria Valley Museum of History.)

Steelhead trout were abundant in Carpinteria Creek, as shown in this *c.* 1900 photograph. It is said that when patrons at Shepard's Inn ordered trout for lunch or dinner, one of the children or employees of proprietors James E. and Belle Wyant Shepard would go out and catch one from the nearby Rincon Creek. (Courtesy Doug Treloar.)

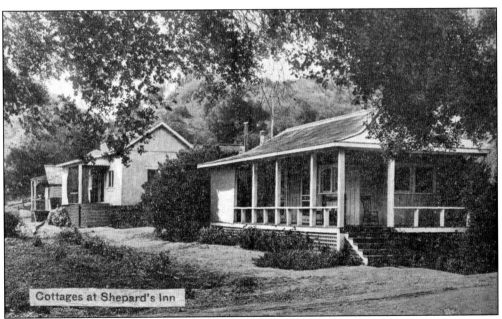

Cottages at Shepard's Inn

Shepard's Inn became a world-famous destination counting Teddy Roosevelt, Lady Astor, Mary Pickford, and Enrico Caruso among those signing its guest list. Originally begun as a stagecoach stop to rest the horses on Casitas Pass Road between Ojai and Santa Barbara, the inn evolved into a local attraction with the establishment of the Carpinteria train depot in 1887. Surreys would taxi guests from the depot to the inn for dining, fishing, and hunting trips. (Courtesy John Fritsche.)

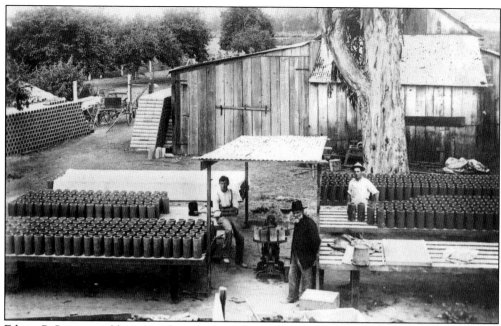

Edwin P. Sawyer and his son, Clarence, introduced the use of ground tile into the Carpinteria Valley, turning it into a family business. They drained part of the slough and laid ground tile to reclaim the land for agricultural purposes. Along with others like L. B. Cadwell, they reduced the slough, or salt marsh as it is known in 2007, to its present tidelands configuration. (Courtesy Dale Goodmanson and Raul Angulo.)

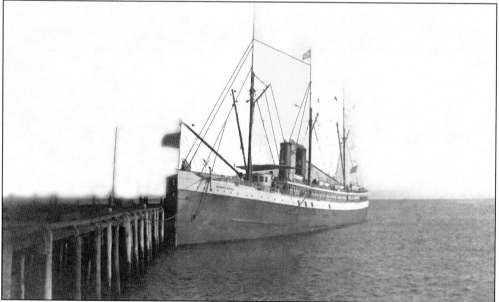

Milton Smith and his brothers built the Serena Wharf in 1878, replacing a wharf that had lasted only a couple of years before being swept away in a sea storm. The Serena Wharf extended 800 feet to accommodate seagoing ships like the *Santa Rosa*, moored at the pier in this photograph. All of Carpinteria's commerce—asphalt, wood, fruits, and vegetables—was shipped to market from the wharf until the arrival of the railroad. (Courtesy Carpinteria Valley Museum of History.)

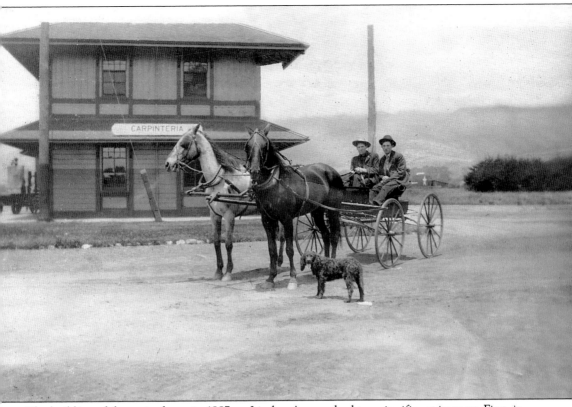

The building of the train depot in 1887 on Linden Avenue had two significant impacts. First, it moved the business center of Carpinteria away from the west end of town, which almost instantly came to be known as Old Town. Second, it devalued the importance of the wharf in Serena as a commercial shipping center, making it obsolete. Serena's bid for township status between Carpinteria and Summerland was stopped dead in its tracks. The situation in Old Town was like a scene from *The Octopus*, Frank Norris's novel of exploitation by railroad tycoons. Russel Heath, who owned the land in Old Town where it was anticipated the depot would be built, expected to be paid well for selling to the railroad. H. J. Laughlin, however, virtually gave the land away to the railroad when the depot was built. Laughlin had his eyes set on the new business opportunities that would develop on Linden Avenue. The surrey in front of the train depot in this photograph probably awaits passengers from the next arriving train. (Courtesy Carpinteria Valley Museum of History.)

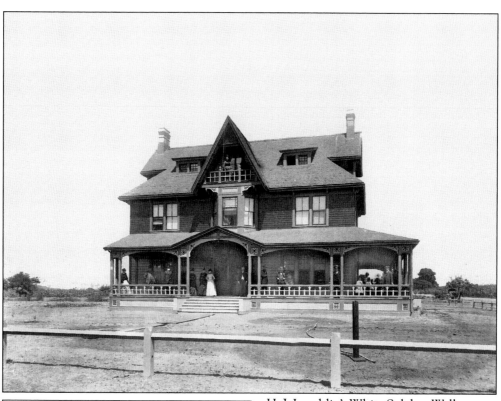

H. J. Laughlin's White Sulphur Well Hotel was completed in January 1887. Six months later, on August 19, the first train came through Carpinteria. The hotel was advertised as having all of the modern conveniences for the traveler, plus its signature sulphur baths. Alas, the hotel burned to the ground in 1894. In 1912, Laughlin built a new hotel on the same site, which would become a Carpinteria institution, The Palms. (Courtesy Santa Barbara Historical Society.)

The residents of Old Town took the loss of their status as the town's center hard. Although relieved of his duties as postmaster, Ed Thurmond continued dispensing mail out of Old Town, collecting mail at the depot on Linden Avenue to bring back to his store. This practice ended by 1892, when Mary S. "Mother" Tobey, pictured at left, was appointed postmaster at the office on Linden Avenue. She became a community fixture, serving for over 20 years. (Courtesy Dale Goodmanson and Raul Angulo.)

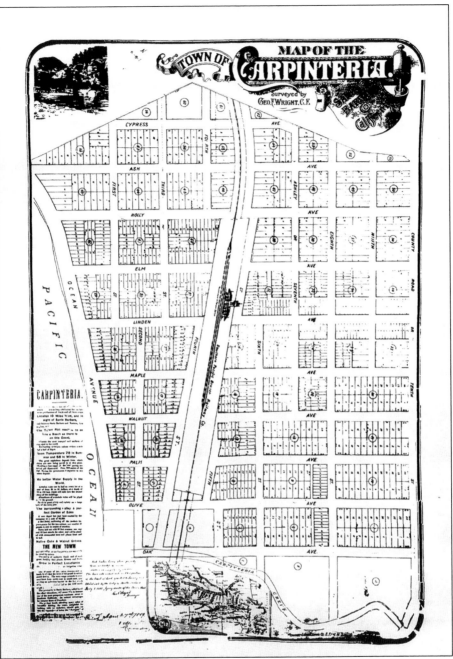

According to Georgia Stockton, "The coming of the railroad set off a spark of new interest in Carpinteria valley. In 1887 the first map of the town site was made by George F. Wright, who named the streets as he laid them out. He numbered the streets running parallel to the ocean and gave names of trees to those crossing them. His plans, if he had any, were not carried out when trees were planted; Ash, Holly and Elm streets have few trees of any kind, Linden Avenue is lined with palms, Maple and Walnut Avenues do not run true to name, and Palm Avenue is lined with jacarandas." Notable on the original map are Ocean Avenue, now under the ocean, and Second Street, which also no longer exists. (Courtesy Carpinteria Valley Museum of History.)

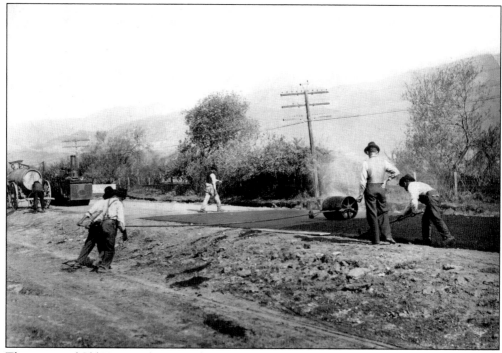

The paving of Old Town is shown in this c. 1920 photograph. Carpinteria asphalt from the local tar pits was used for streets and sidewalks in the valley and throughout California. (Courtesy Doug Treloar.)

The year 1912 is magical in Carpinteria history. The C. D. Hubbard Packinghouse opened that year, converting the P. C. Higgins Packinghouse from a smaller facility to the one seen in this photograph. Also appearing in 1912 were the first business block on Linden Avenue, the Carpinteria Union Grammar School, The Palms hotel, telephone service, Foothill Road, and the Rincon Causeway. (Courtesy Carpinteria Valley Museum of History.)

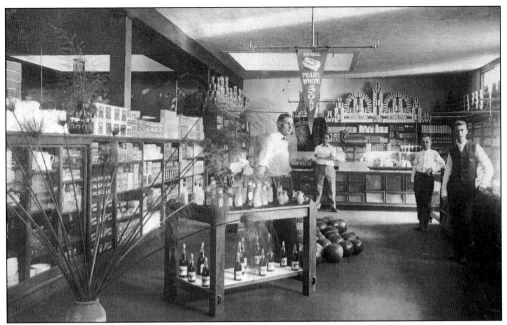

The Hickey Brothers—Wesley, Glen, and Floyd—constructed the first business block on Linden Avenue in 1912, with their dry goods store as the centerpiece, selling everything from hardware to men's and women's furnishings to ice cream. Telephone service in Carpinteria began about the same year. To call the store, all one had to do was dial the number 1. (Courtesy Dale Goodmanson and Raul Angulo.)

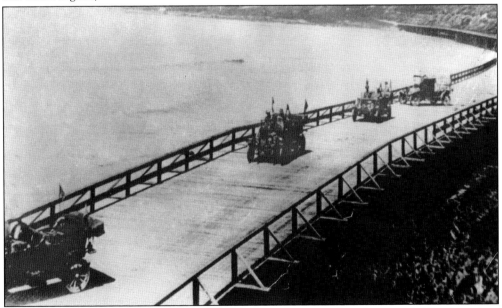

The 1912 grand opening of the Rincon Causeway is shown in this photograph. The ingenious wooden causeway linking Ventura to Santa Barbara through Carpinteria was not without problems. As cars rumbled through it, nails holding the structure together were constantly shaken loose, punching holes in many a tire. According to local lore, it was not uncommon for an automobile to make as many as four tire repairs in a trip across the causeway. (Courtesy John Fritsche.)

Carpinteria has often been described as a sleepy little town. This early-20th-century photograph captures this feeling and also gives a glimpse into the valley's future with the coming of the automobile. Carpinteria's transition into the modern era was jump-started by its geography. It lies about equidistant between the cities of Santa Barbara and Ventura. Telephone lines, electricity, a state-of-the-art school facility, and paved roads for the automobiles were in place by the 1920s. Carpinteria was even at the forefront of aviation history with its very own flying family, the Bauhaus brothers. As it was thrusting forward confidently into the future, there was talk of incorporating the township into a city. A survey conducted around 1915, however, counted only about 450 residents within the township, and the idea was abandoned. A witty line from a high school teacher of the future, Harry McKown, may have summed up the situation best. When asked where Carpinteria is, he replied, "Halfway between Summerland and La Conchita." (Courtesy Ruth D. Rock.)

Two

AGRICULTURE
A LEMON IS KING

The Carpinteria community as we know it today evolved from its agricultural roots. Pioneers panning and digging for gold in California around 1850, while more than likely striking out in pursuit of that precious metal, struck gold in the fertile soil of the Carpinteria Valley.

The growth of agriculture prior to 1900 was a period of experimentation to determine which crops would yield best in the valley. The lima bean was the first commercial crop to put Carpinteria in the limelight. The Henry Fish Seed Company sold lima bean seeds worldwide. By the 1890s, walnuts had become another important commercial product. The Russel Heath Ranch was said to have the largest commercial grove in California at that time. It was the lemon, however—that sour, acidic fruit—that best gave Carpinteria a national agricultural identity.

The California citrus boom of the 1880s is often referred to as the "second California Gold Rush." The state's population soared as the completed railway system brought Easterners west under the slogan "California for health, citrus for wealth." In most citrus-producing areas of California, the orange was king. But in the coastal plain of Carpinteria, it was the lemon. Thanks to Carpinteria's location between the mountains to the north and the Channel Islands to the south, the climate was perfect with its cool, salty ocean breezes that rarely reached a freezing point. The heyday of the lemon industry was between 1930 and 1960, helping the community prosper even during the Great Depression, but eventually the lemon gave up its crown to the avocado and the flower nurseries of the valley.

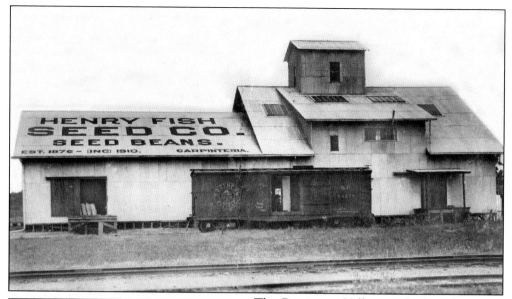

The Carpinteria Valley was the first place in the United States to grow lima beans commercially. Henry Fish established the Fish Seed Company in 1876 and built the packinghouse pictured above for his lima bean business in 1910. It was the largest packinghouse in the valley at the time for Carpinteria's first big cash crop. (Courtesy Carpinteria Valley Museum of History.)

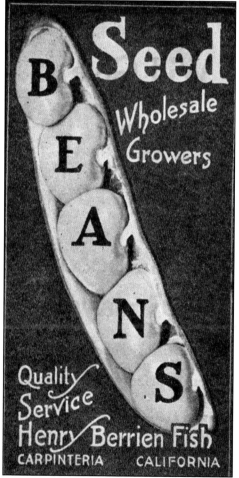

Carpinteria was known as the lima bean capital of the world. The Fish Seed Company limas were patented as the Carpinteria Fordhook. The Fish packinghouse continued under the management of Henry's son, Henry Berrien Fish, until it was changed over to a tomato packing concern, the Deardoff-Jackson Company, in the 1950s. (Courtesy John Fritsche.)

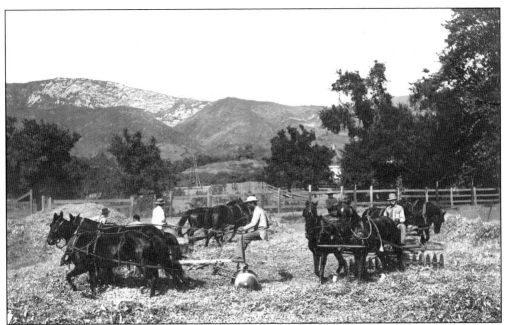

Lima beans were initially threshed by having horses trod over them. Lima bean vines were stacked on the inside perimeter of a corral, then horses were run loose on them to separate the pods. The beans were gathered, bagged, and made ready for market. Later, discs were harnessed to the horses, as shown here. Among the men in the photograph are Mads Christiansen, Jesse Franklin, and Claude Lillingston. (Courtesy Carpinteria Valley Museum of History, photographer Bert McLean.)

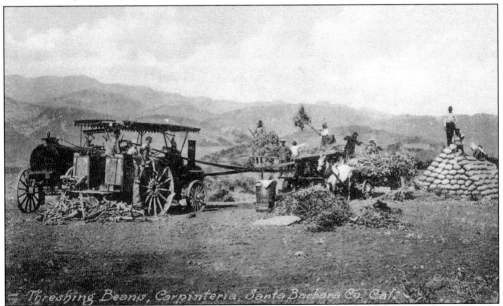

Technological advances introduced the lima bean threshing machine, which replaced the horse in the process. Jack (left) and Neil Bailard are the two young barefoot boys sitting on the wheel of the steam tractor. The thresher tore the vines apart, opening the pods and separating the beans from the chaff. (Courtesy John Fritsche.)

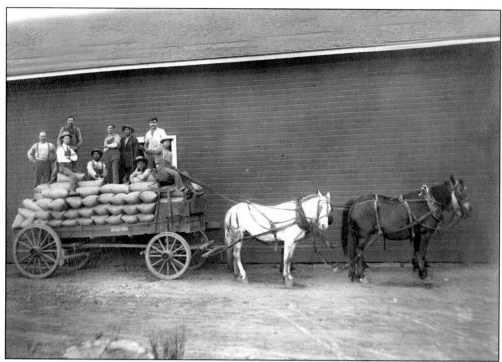

The wagon is loaded with lima bean sacks on the Mark Cravens Ranch, and the horses, Bud and Bill, await direction in this *c.* 1910 photograph. From left to right are John Streeter, Harry Rasor, Fred Hewitt, Jose "Doc" Cota, Charles Mansfield, Abelaedo Ruiz, Jesus Alvarado, George Pyster, and the driver of the team, Juan B. Romero. (Courtesy Carpinteria Valley Museum of History.)

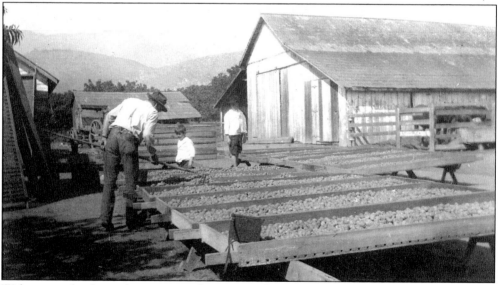

Walnuts are dried on a large tray in this *c.* 1910 photograph on the Bern Franklin Ranch. In 1860, walnuts were introduced to the valley by Russel Heath, who bought seed from the renowned agricultural Wolfskill family of Los Angeles. Carpinteria lore has it that, for a pair of high boots and a saddle, Heath bought eight acres from one of the Spanish-American settlers and planted walnuts. (Courtesy Jack Rock.)

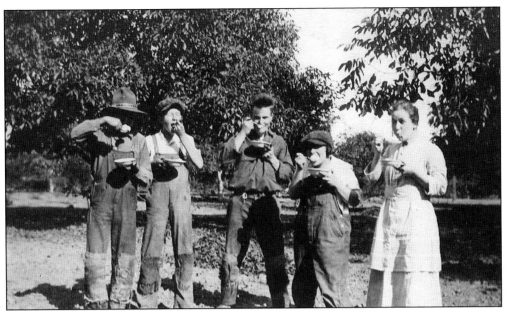

As late as 1930, the local schools closed or dismissed students early during the harvest season to permit the children to gather walnuts. Madge Crawford is pictured second from the right in this photograph c. 1910. (Courtesy Bonnie Milne.)

A walnut tree is dusted on the Rock Ranch in this c. 1920 photograph. The industry grew to the point that two walnut packing plants were built to the west of Walnut Avenue. Both packinghouses closed when the lemon industry became so lucrative to farmers in the valley that walnut farming was largely abandoned. (Courtesy Dale Goodmanson and Raul Angulo.)

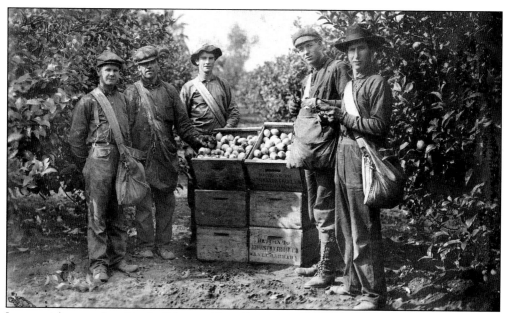

Lemon pickers employed by the Johnston Fruit Company of Santa Barbara are shown at their trade in this photograph around 1917. Many farmers remained loyal to the Johnston Fruit Company despite the establishment of two new packinghouses in Carpinteria after the beginning of the 20th century. (Courtesy Carpinteria Valley Museum of History.)

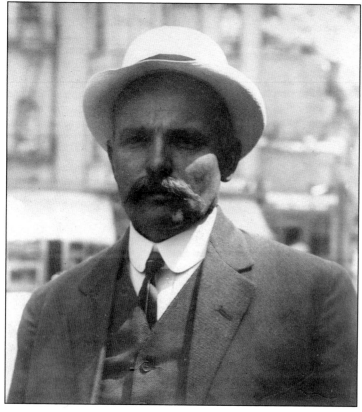

Clark Darwin Hubbard was among the first citrus growers in the state to join the newly established California Fruit Growers' Exchange in 1907, which would eventually come to be known simply as Sunkist. Hubbard established the C. D. Hubbard Fruit Company in Carpinteria in 1912, leasing the P. C. Higgins Packinghouse and expanding its size. He helped commercialize the lemon to prominence in the valley with his flair for promotion. (Courtesy Jonathan Brown.)

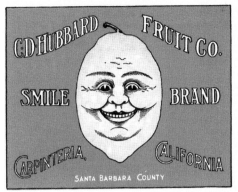

THE CARPINTERIA LEMON LEADS THE WORLD

At the Great Fifth National Orange Show at San Bernardino, California February 17 to 24, 1915, we won:

For the best 24 packed boxes Lemons: Sweepstakes First Prize Challenge Silver Cup and Banner.

For the best 4 packed boxes Lemons: First Prize Silver Cup and Blue Ribbon.

For the best plate of 12 Lemons: Second Prize Ribbon.

For the best p.ate of 5 Lemons: Second Prize Ribbon.

C.D HUBBARD FRUIT CO.
SMILE BRAND
CARPINTERIA, CALIFORNIA
SANTA BARBARA COUNTY

THE C. D. HUBBARD FRUIT COMPANY
CARPINTERIA SANTA BARBARA COUNTY CALIFORNIA

Awards garnered by Carpinteria lemons at the Fifth Annual National Orange Show are promoted on this C. D. Hubbard Fruit Company postcard from 1915. In 1937, the name of the company was changed to the Carpinteria Lemon Association. (Courtesy Jonathan Brown.)

Carpinteria lemons are on display at the Sixth Annual National Orange Show in San Bernardino. Carpinteria lore has it that C. D. Hubbard of the C. D. Hubbard Fruit Company would load lemons into the trunk of his automobile and travel to citrus shows in Southern California, picking and adding the choicest lemons he could find on the ranches along the way. By the time he reached his destination, Hubbard was ready to set up the best quality display of lemons in Southern California. (Courtesy Carpinteria Valley Museum of History.)

George Holsten worked his way up the ladder from picking lemons to managing the Carpinteria Mutual Citrus Association. In 1954, he succeeded Percy Houts, who had been manager since the inception of the Mutual in 1926. He was named Man of the Year by the Santa Barbara County Farm Bureau in 1962. That same year, the Mutual, the Carpinteria Lemon Association, and the Johnston Fruit Company merged into the Santa Barbara Lemon Association. The days of dominance by the lemon industry were waning. (Courtesy George Holsten.)

This *c.* 1930 photograph illustrates the importance of agriculture to the Carpinteria Valley. (Courtesy John Fritsche.)

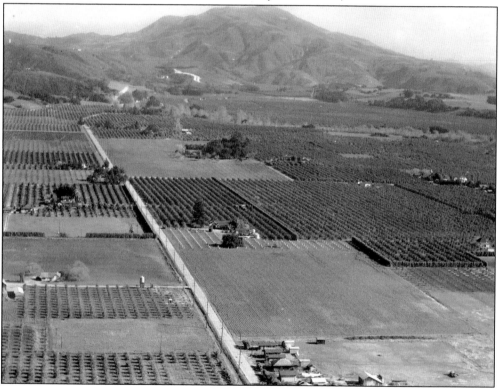

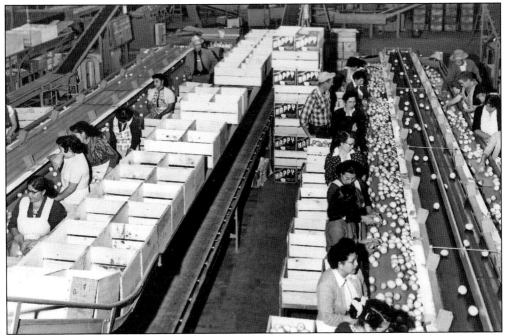

Laws that restricted the Chinese, who made up 25 percent of the labor force in California until about 1900, opened the door to other immigrant laborers. Mexican labor became popular and was a boon to Carpinteria's agricultural industry. This c. 1949 photograph shows lemons being washed and graded. (Courtesy Alice Saragosa-Vasquez.)

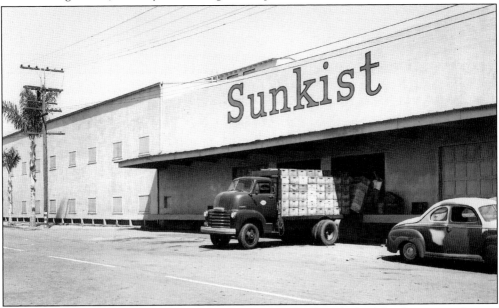

The Sunkist name is prominently displayed outside the loading dock of the Carpinteria Lemon Association around 1950. The Sunkist logo appeared only on labels of top-quality fruit, such as Happy Brand for the Carpinteria Lemon Association or Oceanview Brand for the Carpinteria Mutual Citrus Association. A Redball logo appeared on medium-grade fruit labels, and no logo was used on labels of standard-grade fruit. (Courtesy Alice Saragosa-Vasquez.)

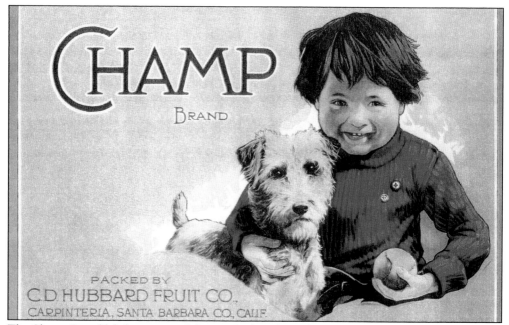

The Champ Brand label represented the standard-grade quality of lemons, as opposed to the higher fancy or choice grades. Standard-grade fruit was blemished in some way and used primarily for baking purposes or for juicing for lemonade. Standard-grade fruit, however, often had the highest quality images, like this one from around 1920, which in the collector's market of 2007 sells for about $800. (Courtesy Jim Campos.)

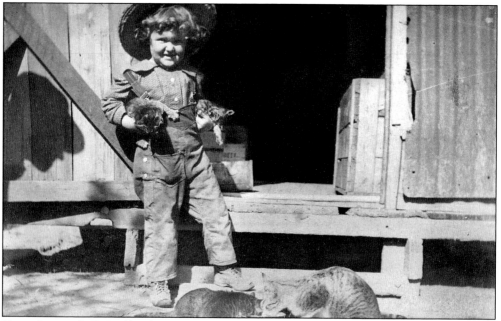

Young Lester, C. D. Hubbard's son, is holding a kitten around 1905. Could this photograph be the prototype for the Champ Brand label? The facial features of Lester in this picture and the boy on the Champ Brand are remarkably similar. Fruit growers often depicted family members on their label designs. (Courtesy Jonathan Brown.)

Oren Cadwell holds a branch of oranges around 1890. He was considered one of the best cultivators of fruits and vegetables in the valley and is credited for introducing the avocado here. While oranges never played a major part in Carpinteria agriculture, the avocado, called the alligator pear in Cadwell's time, eventually became its No. 1 seller. (Courtesy John Rodriguez.)

Large pumpkins and squash were grown to feed livestock in the early days of the valley, as shown here on the Bern Franklin Ranch around 1900. In 1956, near Loon Point, Kay and Lawrence Bailard set up a patch where customers went out into the field to pick their own pumpkins for Halloween, garnering national attention in *Sunset* magazine. Pumpkin patches set up in this way have since become a Carpinteria tradition. (Courtesy Carpinteria Valley Museum of History.)

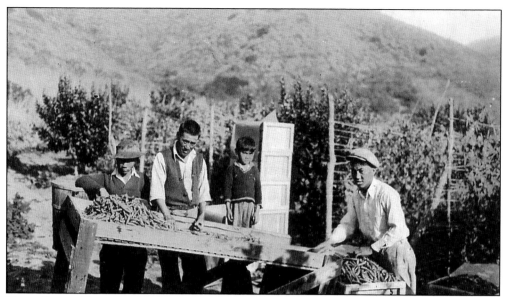

Kijuro Ota and his sons Kenji, Minoru, and Tom cull peas in this c. 1920 photograph. Japanese farmers rented land in the valley to grow produce, which they would sell in Los Angeles markets. Families like the Otas were eventually allowed to buy land in the valley. In 2007, many families of Japanese descent are prominent in the valley's flower industry. (Courtesy Tom and Mary Ota.)

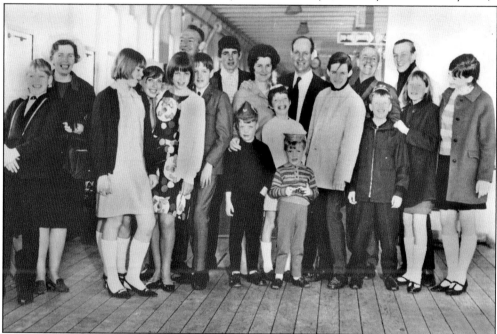

The Van Wingerden and Van Koppen families, about 30 members strong, came to Carpinteria in 1967, determined to bolster family fortunes via the flower industry. Pictured here is part of the Van Wingerden group, destination Carpinteria. They bought land on the original Russel Heath property and cut down the last of the walnut orchards that were there, putting in greenhouses. Currently the flower industry vies with the avocado industry as the No. 1 agricultural business in the valley. (Courtesy Yoze Van Wingerden.)

Three

CARPINTERIA'S MEXICAN HERITAGE

Carpinteria's glamorous neighbor 10 miles to the north, Santa Barbara, maintains and promotes its Spanish heritage through architecture, several famous and well-preserved monuments—the Spanish Mission, Presidio, and courthouse—and its annual Old Spanish Days Fiesta. Although the families of the Presidio soldiers from Santa Barbara first settled in Carpinteria after the Chumash period, the Spanish influence did not root itself in the community's traditions and celebrations. Instead, Mexican cultural traditions found their way into the community consciousness.

The Mexican presence in Carpinteria began to be felt by 1920. Labor was needed to repair the railroads, build roads, remove brush and rubble, and most significantly help farmers with the tending of their crops. The lemon industry in particular was a year-round business and benefited from a non-migratory labor pool. At the same time, Mexico was going through the Mexican Revolution and its long aftermath. Uprooted Mexican families, some with family members running a step ahead of a firing squad, found safety and work across the border. A Mexican colony developed in Carpinteria, taking hold in Old Town and the vicinity around Seventh Street, areas abandoned by their Anglo and Spanish predecessors.

Mexican families settling in Carpinteria were sometimes excluded from equal participation in the community. For example, "Whites Only" policies were enforced in the seating arrangement at the local movie theater. Mexicans were prevented from buying real estate in certain areas of the community, and in 1935, a school was built specifically for their children. Social equality, however, dramatically improved after their display of patriotism during World War II, which included acts of heroism in Europe and the Pacific.

Carpinterians of Mexican descent have contributed greatly to the community. In 2007, Carpinteria has a decidedly Mexican flavor as a city that is integrated and inhabited about equally by Anglo families and families with ties to Mexico.

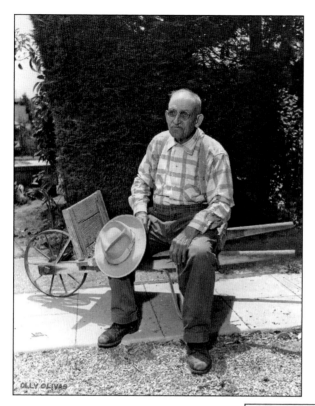

Expectación Alvarado worked on the construction of the Southern Pacific railroad, raising enough money to bring his family from Mexico to Carpinteria in 1900. In 1905, he bought the Octagon House, an eight-sided oddity at the corner of Linden Avenue and Foothill Road. Alvarado predated the tide of Mexican immigrants who were to come later. He holds the distinction of having the only Spanish-surnamed street in Carpinteria, Alvarado Road. (Courtesy Carpinteria Valley Museum of History.)

Pedro Ruan, seated on the left with a guitar around 1925, worked on the J. W. Bailard Ranch. Celebrations by the laborers and their families usually included a mariachi band and Mexican-style barbecue. Like Ruan, who had served as a judge in Mexico, many Mexican laborers in the first wave of immigrants coming to the United States as a result of political unrest and economic duress in their home country were highly educated. (Courtesy Sal and Delia Campos.)

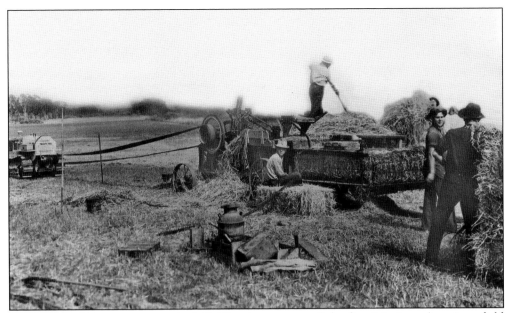

Steve "Dudie" Romero, an original Californio, was one of the first Mexican American field bosses in the valley. His son, Steven Jr., would later serve as the constable at the justice court in Carpinteria. Around 1935, Dudie sits on a bale of hay while George Ruano tosses hay directly above him. Ruano's brother, Stanley, served in the army during World War II and sparred with the heavyweight champion of the world, Joe Louis, as part of a series of exhibition bouts with servicemen to boost morale for the war effort. (Courtesy Carpinteria Valley Museum of History.)

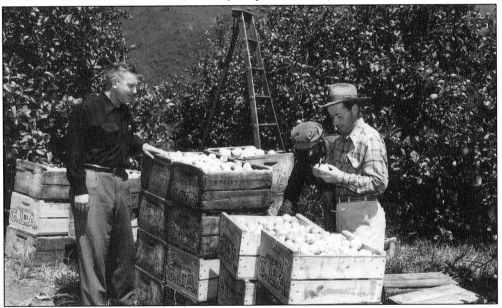

Among the political refugees from Mexico was Jesus Gonzales, who settled in Carpinteria in 1929. Gonzales was named the field superintendent of the Carpinteria Lemon Association and manager of the South Coast Growers Association by the 1940s. In this c. 1950 photograph, he is shown inspecting a lemon fruit box with Wallace McIntyre, manager of the Carpinteria Lemon Association. (Courtesy Alice Saragosa-Vazquez.)

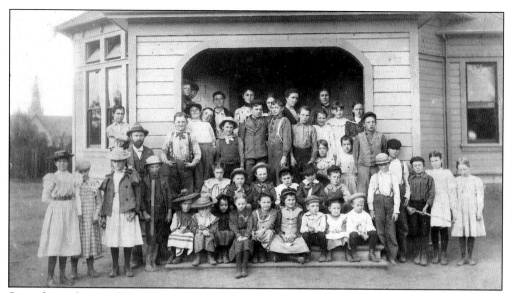

Spanish-speaking and English-speaking children originally shared the Carpinteria schools. The wave of immigrants induced by the availability of agricultural work in the valley, however, created crowded conditions at the schools. A new school at the corner of Carpinteria Avenue and Palm Avenue, the Union Grammar School, was built in 1912. Aliso, at the corner of Carpinteria Avenue and Walnut Avenue, shown here around 1903, was converted into a school for the Mexican children by 1920. (Courtesy Carpinteria Valley Museum of History.)

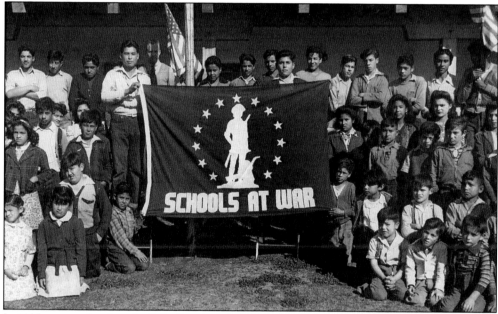

In 1935, a new school was built in Carpinteria. This school was built specifically for the Mexican children of the community. The old Aliso School was razed and the new Aliso School constructed away from the town center at its current location at the point where Seventh Street meets Carpinteria Avenue, near the Mexican neighborhoods of Old Town. Most of the older boys pictured in this photograph would go on to serve in the armed forces during World War II. (Courtesy Lawrence Cervantes.)

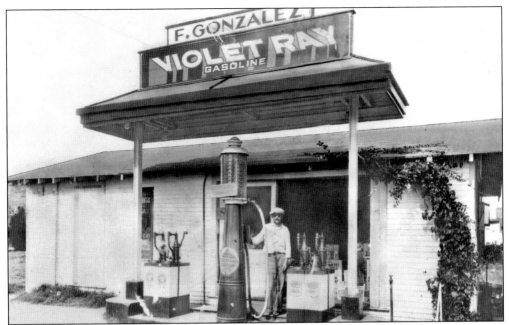

Francisco Gonzales was the proprietor of the Violet Ray service station and market from 1929 to 1931. The Violet Ray, along with Osuna's Market, served the Old Town neighborhoods beginning around the 1930s. For decades after, under many different owners, the business located at the point where Carpinteria Avenue and Seventh Street meet was frequented by children running across the street from Aliso School to buy candy, soda pop, kites, and baseball cards. (Courtesy Carpinteria Valley Museum of History.)

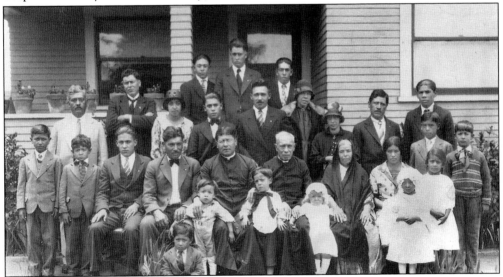

Members of the Molina, Raya, and Saragosa families are photographed with the two St. Joseph's Parish priests, Padre Francisco Escobar and El Cura Elizondo, around 1930. The gathering is at the Raya home across from the church at the corner of Seventh Street and Ash Avenue. The bond between the Mexican families and the Catholic Church was particularly strong because many had fled to the United States during the Mexican Revolution as a result of the rift there between church and state. (Courtesy Alice Saragosa-Vazquez.)

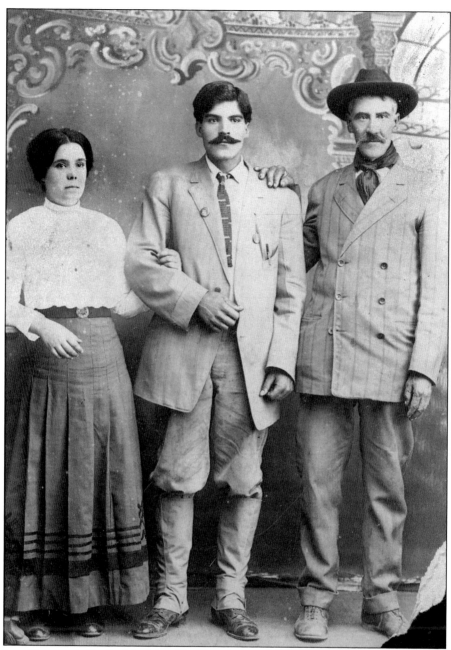

Santiago Campos is flanked by his wife, Trinidad, and father-in-law, Cresenciano Gonzales. In 1933, Campos paid $50 to raze the Catholic church on Santa Monica Road at Upson Road (formerly the Methodist church). He paid for the right to tear the church down and acquired the church's lumber, its stained-glass windows, and the wainscot paneling that lined the interior. He carted the lumber home by horse to build his family home on Ninth Street. The stained-glass and paneling he saved. When the St. Joseph's Catholic Church was built on Seventh Street about a year later, Campos donated the stained-glass windows and the wainscot paneling to the new church. The ornate gothic windows and interior wainscot paneling can be seen this day in the St. Joseph's Chapel on Seventh Street. (Courtesy Sal and Delia Campos.)

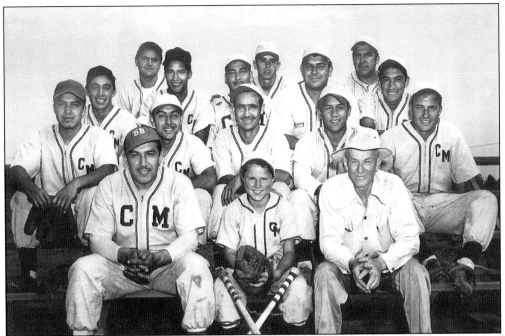

The Carpinteria Merchants baseball team dates back to the early 1900s. Pictured around 1940 are, from left to right, the following: (first row) Tony Velasquez, Teddy Moore, and Ross Stone; (second row) Joe 'Pops' Granada, Reg Velasquez, Joe Goena, Chester Decayama, and John Bianchin; (third row) Danny Manriquez, Ed Arellano, Al Jaciento, Chon Robledo, Bobby Sangster, Gerald Velasquez, Joe Granada Sr., and Richard Carrillo. (Courtesy Ed Arellano.)

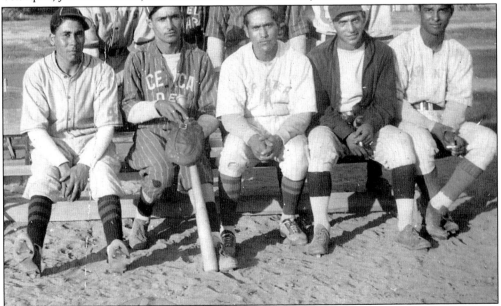

The Cerca del Mar baseball team was organized for a short period of time in the early 1930s. Like the Carpinteria Merchants team of this time period, the players were an ethnically integrated mix of the best athletes in the valley. Shown in this photograph are, from left to right, Albert Sanchez, Joe Goena, Sabino Garcia, Joe Perez, and unidentified. (Courtesy Ernie Sanchez.)

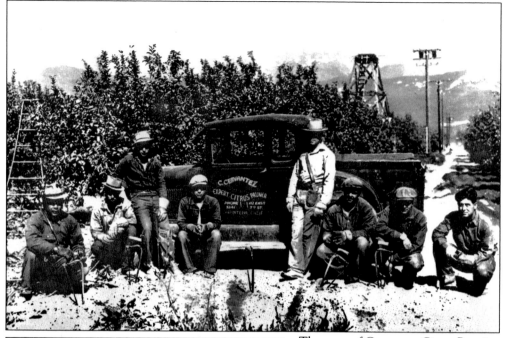

The crew of Cervantes Citrus Pruning are having their picture taken c. 1940. They are, from left to right, ? Maravilla, Louis Soto, Leo Perez, ? Mariscal, Candelario Cervantes, Louis Campos, David Campos, and unidentified. As the United States entered World War II, businesses owned by Mexican Americans began to sprout up in Carpinteria. (Courtesy Sal and Delia Campos.)

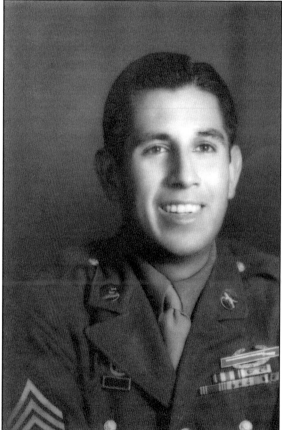

Jess Ortiz served in the armed forces from 1941 to 1946 as a staff sergeant. He is remembered as the most highly decorated of the young Carpinterians of Mexican descent who enlisted in the service during World War II. He was awarded the Silver Star, Bronze Star, and a Purple Heart with two clusters (meaning he was wounded three times) for valor in the battlefields of Europe and the Pacific. (Courtesy Dolores Macias.)

Sal Campos entered the navy underage at 17, serving in the Pacific theater of World War II. His cousin, Leslie Marquez, entered at the age of 16. The youth of that time merely needed a parent's signature to enlist. Campos is pictured manning an anti-aircraft gun on an LSM ship in 1945. His LSM reached the beach of Nagasaki after the atomic bomb was dropped on that Japanese city, prior to the landing of the securing army and marine forces. (Courtesy Sal and Delia Campos.)

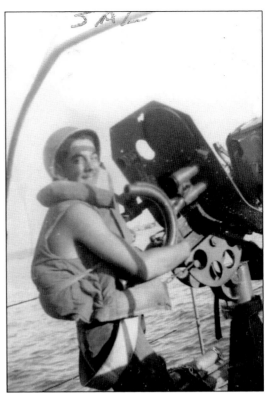

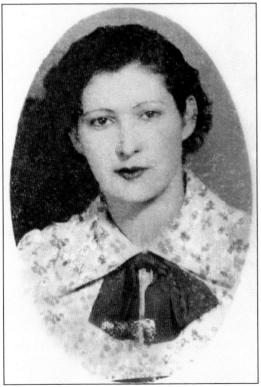

The World War II effort was not won on the battlefield alone. Jenny Saragosa, pictured around 1940, and her coworkers at the Carpinteria Lemon Association wrote messages of encouragement to the servicemen overseas on the wrappers that protected the fruit from becoming moldy in the packing crates. Many servicemen responded back and kept correspondence going. Olly Olivas, serving in Germany, and Sal Campos in Saipan, remember seeing lemon crates from their hometown of Carpinteria. (Courtesy Alice Saragosa-Vazquez.)

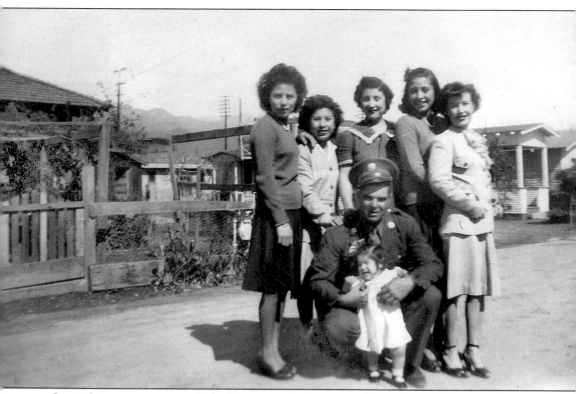

Louis Campos saw a great deal of action in the European theater of World War II, winning a Bronze Star for bravery and three Purple Hearts. In this 1940s photograph, he is pictured upon his return home on Ninth Street, known as Hollywood to its residents, with his wife Margaret on the far right and daughter, Gloria, in his arms. The other ladies in the photograph, from left to right, are Aurora Soto, Jessie Escareño, Lucy Gonzales, and Anita Soto. Campos, in uniform, makes a sharp contrast to the poor neighborhood surrounding him. To most of the families living in or around Ninth Street, the name "Hollywood" was perceived as a slam because the street was filled with possibly the poorest homes in the valley. It was accepted, however, as a term of endearment by its residents and has stuck through the decades. The driver of the Spreitz Santa Barbara bus line, upon making his daily stop in the 1950s at Ninth Street and Reynolds Avenue, would shout, "Next stop Hollywood and Vine." There are many stories about how Ninth Street came to be known as Hollywood. Most likely, the name was given in 1916 when a Hollywood film crew staged a battle scene there. Reynolds Avenue, the cross street at the top of Ninth Street, has its own peculiarity. At 150 feet in length, it is one of the shortest avenues in the world. It is hardly a destination for anyone traveling by automobile, yet one of Carpinteria's main entrance points off the southbound 101 freeway is the Reynolds Avenue exit. (Courtesy Sal and Delia Campos.)

Servicemen of Mexican descent returned from World War II with an entrepreneurial spirit. Marty Macias is pictured in front of the Valley Barbers barbershop. He and his partner, Cipriano "Zip the barber" Gonzales, served the community for about 50 years at their location next to the movie theater on Carpinteria Avenue. Many Mexican American owned businesses became a part of the Carpinteria landscape after the war. (Courtesy Martin Macias family.)

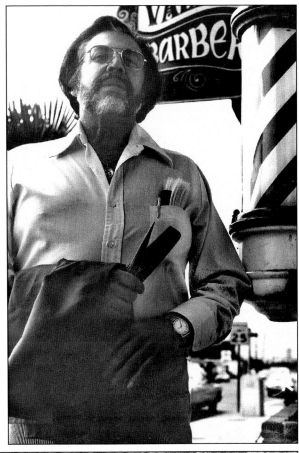

The employees of the Carpinteria Lemon Association had this group picture taken inside the packinghouse in 1949. Many of the people pictured here remained with the packinghouse when it became the Santa Barbara Lemon Association around 1962 and stayed with it until it burned down in 1978. (Courtesy Carpinteria Valley Museum of History.)

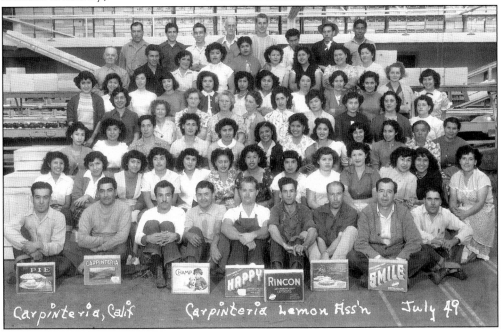

47

Joe Morales is pictured in the Carpinteria Lemon Association's repair garage around 1950, where he was in charge of maintenance. The garage was on Palm Avenue across the street from the packinghouse and remains a popular repair garage to this day. Morales was active in helping desegregate Carpinteria's schools, which were integrated in 1947, and he became a school board member in the early 1950s. (Courtesy Alice Saragosa-Vazquez.)

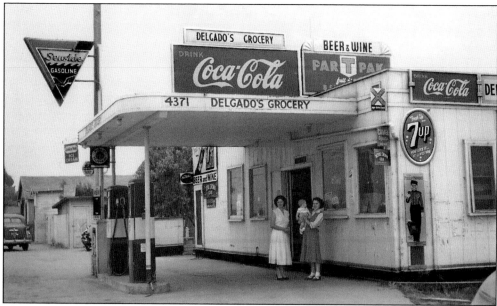

There were no Mexican restaurants in Carpinteria until Delgado's Seaside Service Station and Grocery was sold in favor of a tortilla factory and take-out restaurant in 1965, bearing the same family name. In the early days of the Carpinteria Valley, when people spoke of beans, they meant the lima bean. When one speaks of beans today, it is most likely in reference to the refried pinto bean, the favored bean in Mexican cuisine. Pictured above around 1950 from left to right are Christina and Susan Delgado, who is holding Ruben Gonzales. (Courtesy Christina Castellanos.)

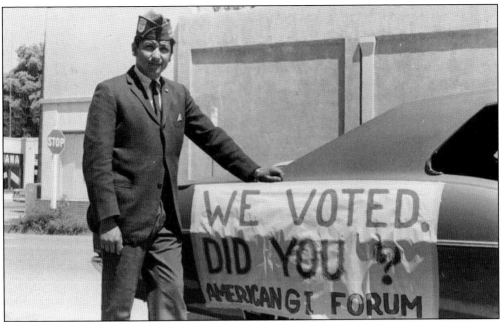

Veterans of war formed the membership of the American G.I. Forum. The Carpinteria chapter was started in 1968, thanks to the organizational efforts of Joe Vazquez. He is pictured here in the organization's inaugural year. It grew to 65 members, the largest chapter in California. The civic organization was active in voter registration drives and scholarships for students in need and each year presented the American G.I. Forum trophy to the Most Valuable Player of the Carpinteria High *v.* Bishop Diego football game. (Courtesy Olly Olivas.)

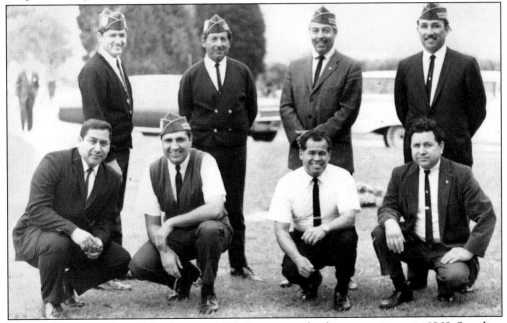

Several charter members of the American G.I. Forum pose for this group picture in 1968. Standing are, from left to right, Joe Vasquez, Henry Camacho, Olly Olivas, and Albert Chavez; (first row) Marty Rosales, Joe Macias, Mike Ramirez, and Joe Escareño. (Courtesy Olly Olivas.)

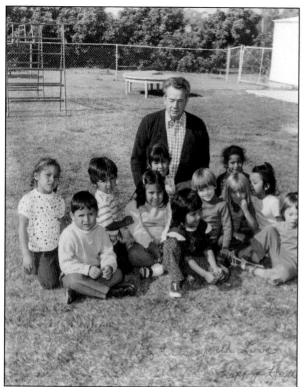

Cres DeAlba is pictured with children of the Head Start program, c. 1970. He was a two-term school board member, active in the Community Action Committee, a founder of the Boys and Girls Club, and a youth sports league leader. After the 1969 flood, he escorted California governor Ronald Reagan around Carpinteria and helped secure funding for the city's recovery. DeAlba was named Carpinterian of the Year for his many contributions to the community. (Courtesy DeAlba family.)

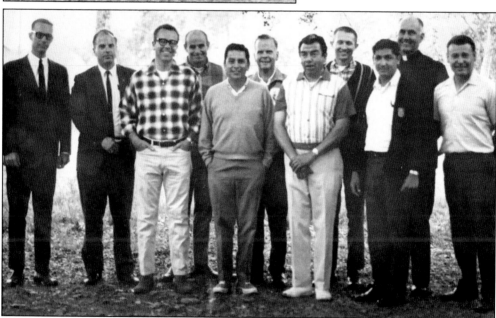

The American G.I. Forum hosted a barbecue gathering at Lions Club Park to introduce itself to other Carpinteria civic groups in this 1969 photograph. Among the many dignitaries attending the event were, from left to right, David Minier, Jack Arnold, Dr. Jim Gray, Dr. William Carty, Henry Medel, George Clyde, Lucio Medel, Mayor Allan Coates, Joe Vazquez, Fr. Francis Roughan, and future mayor and charter G.I. Forum member Ernie Wullbrandt. (Courtesy Olly Olivas.)

Four

DOWNTOWN CARPINTERIA

It was the automobile that handled the initial introductions between Carpinteria and its downtown. Although there had been blacksmith shops, groceries, feed stores and other farm-related enterprises in the area that would become Carpinteria's commercial hub, it was Henry Ford and friends who really created the need for the city's business district.

During the heyday of the Coast Highway's meanderings through midtown Carpinteria, the city had 14 filling stations, 9 automobile repair shops, a Ford dealer, a Chevrolet agency, and a tractor retailer. Not surprisingly, the proprietors of these businesses, almost to a man, sported nothing but prosperity-driven grins. Motels and eateries were natural spin-offs of Carpinteria's automobile-driven economy, and they all flourished as well.

Prevailing wisdom has it that motorists out of Los Angeles often found their gas gauges dipping precariously as they eased past the Rincon at the southern end of Carpinteria, necessitating brief stops at one of the valley's gas stations. And this, in turn, often led tourists to seek out a light snack, which frequently culminated in a stomach-settling beach stroll, and the rest, as they say, is history.

The net result of this boom of Coast Highway businesses was the establishment of a visitor-serving economy. The Coast Highway's entrepreneurial explosion also took a turn toward the beach at the valley's first stoplight, located at the corner of the Coast Highway and Linden Avenue. It was a turn, in retrospect, that seemed almost predestined.

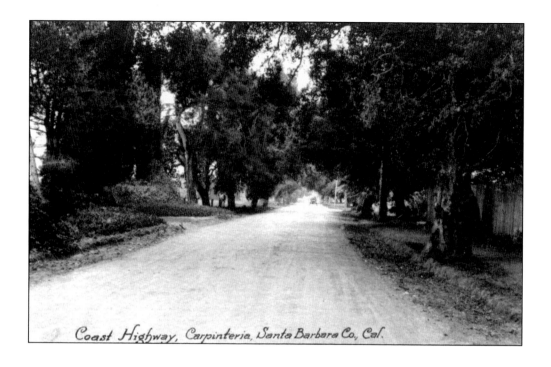

Coast Highway, Carpinteria, Santa Barbara Co., Cal.

Hollywood has Sunset and Vine, and Carpinteria has Linden and Carpinteria Avenues. Carpinteria Avenue has also been known as the Coast Highway and Highway 101 during its lifetime. The top photograph is the Coast Highway, and the one below it is what one saw in 1910 when looking up Linden Avenue toward the mountains. (Above, courtesy Sey Kinsell; below, courtesy Carpinteria Valley Museum of History.)

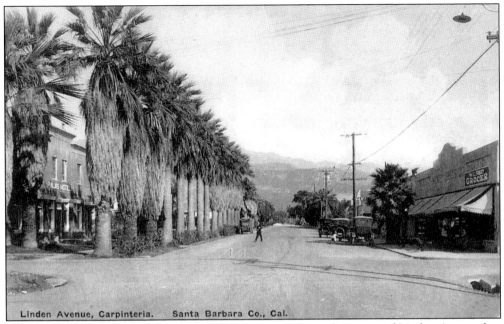

Linden Avenue, Carpinteria. Santa Barbara Co., Cal.

The Palms restaurant, which is located on the corner of Seventh Street and Linden Avenue, has been an institution in Carpinteria for decades. It is barely visible in its infancy behind the wall of palms that are its namesake. (Courtesy Sey Kinsell.)

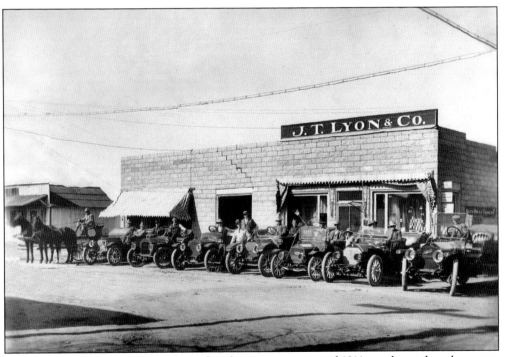

J. T. Lyon and Company, a general merchandise store seen around 1911, was located on the corner of today's Linden and Carpinteria Avenues. Horseless carriages dominated, but there was one traditionalist to the far left. (Courtesy Carpinteria Valley Museum of History.)

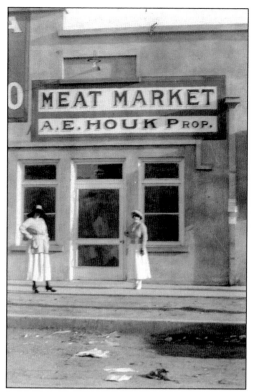

These two ladies arrived early to beat the crowds at Houk's Meat Market on Linden Avenue around 1912. (Courtesy Bonnie Milne.)

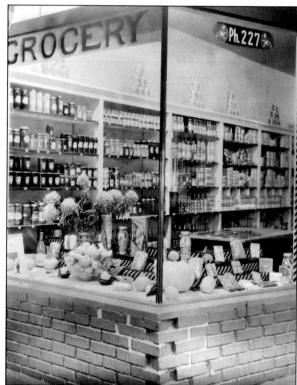

A shot of the Tobey Grocery, *c.* 1915, verifies the Tobey family's mastery of marketing. Note the three-digit phone number in the window, "Ph. 227." (Courtesy Carpinteria Valley Museum of History.)

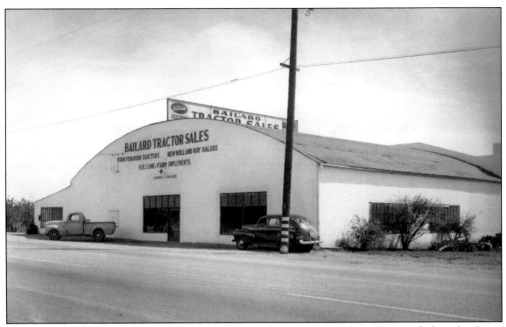

Bailard Tractor Sales was one of the first businesses motorists passed as they traveled on the Coast Highway into Carpinteria from the south around 1940. This building was originally a hangar at the Carpinteria Airport. (Courtesy Andy Bailard.)

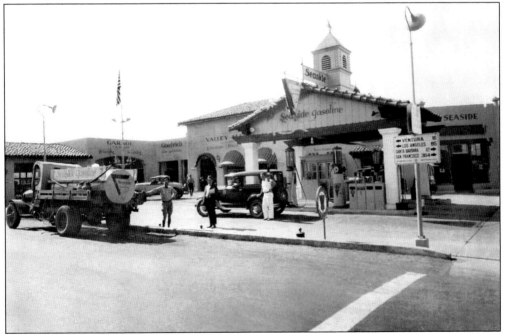

The Carpinteria Seaside Station anchored the city's first strip mall, or something akin to it, at the corner of the Coast Highway and Linden Avenue in the 1920s. The Valley Meat Market was one of the businesses in the complex. Mix Van de Mark is leaning on the gas truck. If there are any doubts about whether this is Carpinteria or not, check the highway mileage sign. (Courtesy Winfield Van de Mark.)

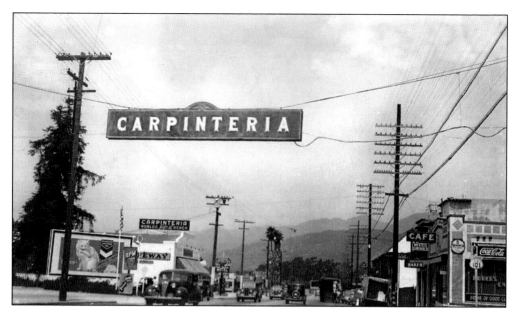

Carpinteria's outlook was spectacular, and its potential limitless—Carpinterians knew it then, and they know it now. Linden Avenue runs the same direction as the Carpinteria sign. The cars are traveling along the Coast Highway. Note the "World's Safest Beach" sign on top of the Safeway, c. 1935–1940. (Courtesy Lawrence Cervantes.)

Local market makes good c. 1950. The Valley Market demonstrated that treating customers like family was good marketing strategy. And if the kids minded their Ps and Qs at the market, there might be a trinket in it for them at the nearby Ben Franklin's. The clock that topped the tower at the market carried the letters of Carpinteria as numbers 1 through 11 on its face. (Courtesy Sey Kinsell.)

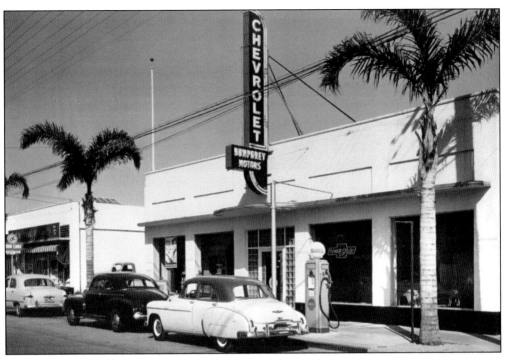

Humphrey Chevrolet was located on Linden Avenue one block below the Coast Highway. It was a full-service dealership owned by W. W. Humphrey. One could buy a new Chevy and then fill it up at the curb around 1950. (Courtesy Jennifer DeSandre.)

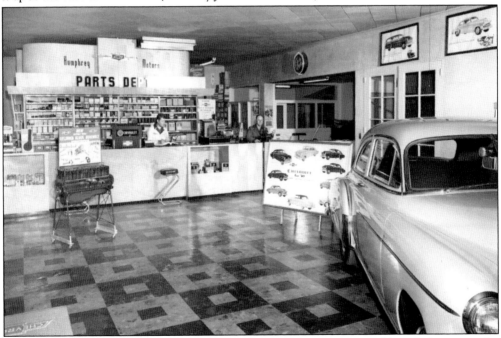

The spotless interior of the Humphrey Chevrolet Parts Department could easily have passed a health inspector's restaurant standards. That's Don Christiansen on the left and W. W. Humphrey on the right, behind the counter around 1950. (Courtesy Bruce and Peggy Humphrey.)

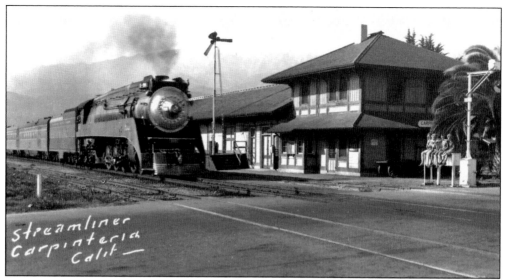

A Southern Pacific Daylight, c. 1940, arguably the most beautiful train ever built, eases into Carpinteria Station, elevation seven feet above sea level, on its way to Los Angeles. Some local youngsters cheer the arrival of this wheeled work of art. The depot was located on Linden Avenue just below Fifth Street, approximately three blocks from the beach. (Courtesy Carpinteria Valley Museum of History.)

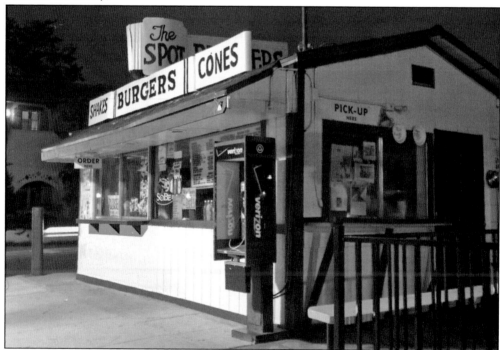

Cecil Hendrickson, who opened the Spot around 1950, would be happy to know that its burger tradition endures. Julia Child's endorsement of the Spot burger certainly helped, but it is the thousands of satisfied repeat customers that really keep the ball rolling. The Spot's location on Dorrance Way and Linden Avenue marks the southern extremity of the business district. (Courtesy photographer Tom Moore.)

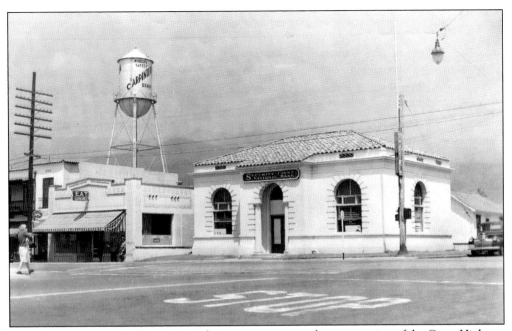

The water tower pictured here is one of two structures near the intersection of the Coast Highway and Linden Avenue that wore the ever-present slogan, "Carpinteria, the World's Safest Beach," on its exterior. The Security First National Bank and a café whose neon sign suggests that folks "Eat" are also pictured, c. 1947. (Courtesy Carpinteria Valley Museum of History.)

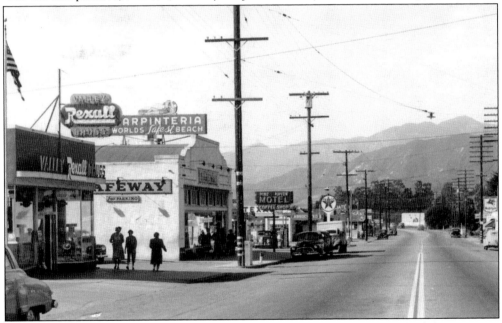

This block overflows with visitor-serving amenities. The Rexall Drug on the left is just past the corner of the Coast Highway and Linden Avenue. The large white building across the alley from the Rexall is a Safeway market. (Note the updated version of the "World's Safest Beach" sign.) The Pine Haven Motel and Coffee Shop and the Texaco Station are Safeway's immediate neighbors to the west. (Courtesy Carpinteria Valley Museum of History.)

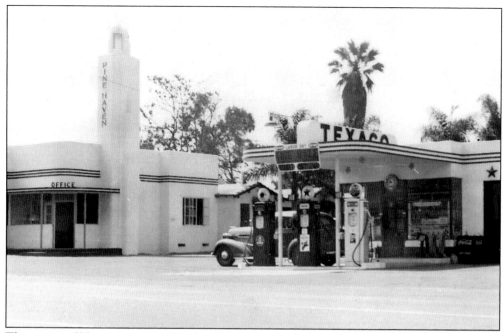

The corner of Elm Avenue and the Coast Highway was a tourist's delight. Folks could fill up the tank at Texaco and, just steps away, grab a bite to eat at the Pine Haven Coffee Shop around 1930. (Courtesy Carpinteria Valley Museum of History.)

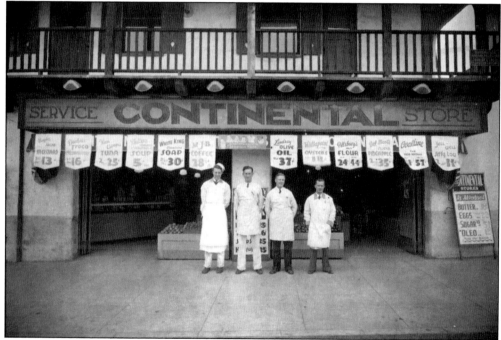

The Continental store was located in the Alcazar Theatre Building, which was situated at the corner of Elm Avenue and the Coast Highway. Three of the items no fiscally responsible Carpinterian could walk away from were tuna, 2 for 25¢, White King Soap, a two-and-a-half-pound box for 30¢, and MJB Coffee, 28.5¢ a pound. (Courtesy Carpinteria Valley Museum of History.)

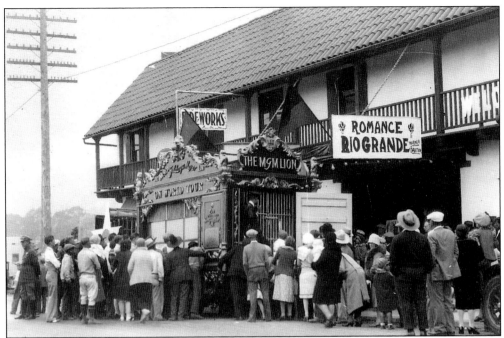

The Alcazar (the local theatre's original moniker) and the Plaza (its current name) are probably the names that are best known to locals, although the Ritz, the Del Mar, and the Tradewinds are also in the running. In this c. 1928–1929 picture, the theater draws a crowd. And why wouldn't it? The touring MGM Lion, in the flesh, is in the lavishly decorated cage out front. Another drawing card in the early years was the theater's proprietor, actor Oliver Prickett of Ma and Pa Kettle fame. (Courtesy Carpinteria Valley Museum of History.)

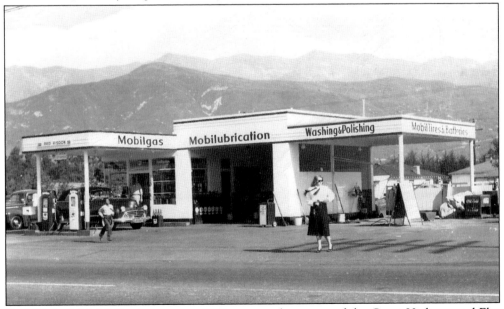

Fred Risdon's Mobil Station, seen c. 1950, was on the corner of the Coast Highway and Elm Avenue. Fred was the point man in a line of service station proprietors. Son Jack and grandsons Don and John all followed in Fred's footsteps. (Courtesy Jack Risdon.)

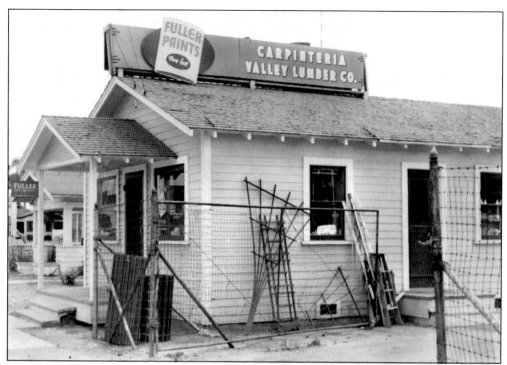

Marcus Latham ran Carpinteria Valley Lumber for decades. Was he a good man to work for? His son Bob, Stanford educated and a player on the 1952 Rose Bowl team, had certainly experienced the glamour of life in the big city, but when all was said and done, he came home and spent the rest of his days working at Carpinteria Valley Lumber with his dad. The lumberyard was located on the corner of the Coast Highway and Holly Avenue. (Courtesy Pat Latham.)

Welcome to Carpinteria! The little town has it all: Gas, food, lodging, the "World's Safest Beach," and tires—Good tires—c. 1940. (Courtesy Carpinteria Valley Museum of History.)

The Monte Vista Dairy, though not located downtown, served its products all around town. Started in the 1920s by Clarence Sawyer, it was located on Linden Avenue across from St. Joseph's Church. At different times, the following Italian men and their families owned and operated the dairy: Victor Vido, Luigi Silvestrine, Mateo Fabbian, Giacomo Zanella, and Augusto Surian. (Courtesy Carpinteria Valley Museum of History.)

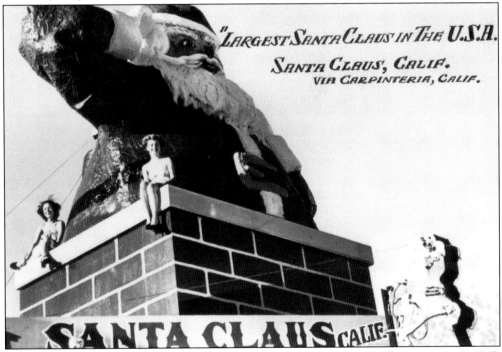

Carpinteria's 18-foot-tall, two-and-a-half-ton Santa began bestowing goodwill on motorists in 1948. He was stationed on Highway 101, northwest of downtown Carpinteria. Many Carpinterians are still reeling from the trauma precipitated by Santa's recent move to Oxnard. One would suspect that the ladies sitting on Santa's chimney received a stern scolding from the OSHA folks when they came down off their perch. (Courtesy John Fritsche.)

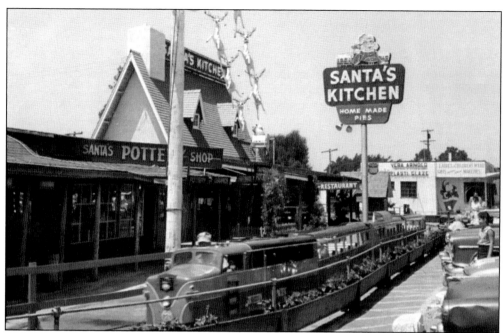

Astute local entrepreneurs were quick to piggyback on Santa's popularity. Train rides, date shakes, world-class meals, olives, western novelties, and toys—let's not forget toys—were all available at Santa Claus Lane in its heyday during the 1950s. (Courtesy Dave and Louise Moore.)

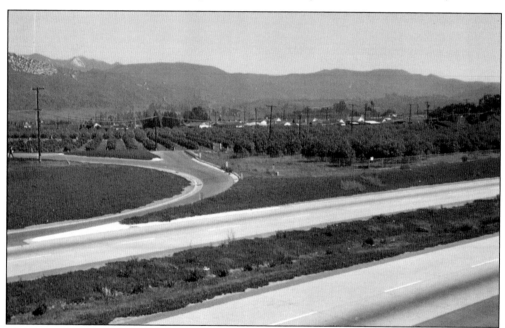

The Coast Highway moved off Carpinteria Avenue in the mid-1950s and became a freeway, pictured here in the 1960s. California is littered with towns whose fates were sealed when the freeway lured folks away from their downtowns. Not so in Carpinteria. Businesses had been established, and a classic beach-town identity solidified. Carpinteria was open and ready for business. (Courtesy John Fritsche.)

Five

THE WORLD'S
SAFEST BEACH

Carpinteria took especially good care of its kids during the summer. Mothers told their youngsters to take off their dress shoes and keep them off until September. And as far as watches were concerned, Carpinteria's kids didn't need them. At 10:00 a.m. the Southern Pacific's whistle reminded them that it was time to roll out of bed and get to the beach. At noon, the fire station siren went off—lunch. At 2:00 p.m. Barbara Boyd had her story hour at the main beach, and at 4:00 p.m. the Southern Pacific and its whistle made an afternoon run—time to go home, refuel, and bed down in preparation for the upcoming day's festivities. Timex couldn't have done it any better.

Carpinteria did pretty well by its tourists as well, which might explain why it has been a favorite camping destination for decades. Mention you're from Carpinteria to strangers, and, as often as not, folks will rhapsodize, "Carpinteria, I love that town; my parents used to take us camping at the beach there as kids. I've never forgotten those vacations."

The dilemma that faced both the natives and the tourists was not what they would do on any given day, but rather what they would do first. Fishing, rafting, bodysurfing, surfing, snorkeling, spearfishing, canoeing, hiking, sand-castling, tide pooling, shell collecting, and skimboarding were all possibilities. Some folks even rode their horses, motorcycles, and jalopies on the beach.

In fact, in the early 1900s, folks were baptized at the beach, and in 1928, the Cerca del Mar Beach and Social Club was opened, which meant one could, on a slightly less religious note, dine and dance at the "World's Safest Beach."

Talk about one-stop shopping; Carpinteria beach had it all.

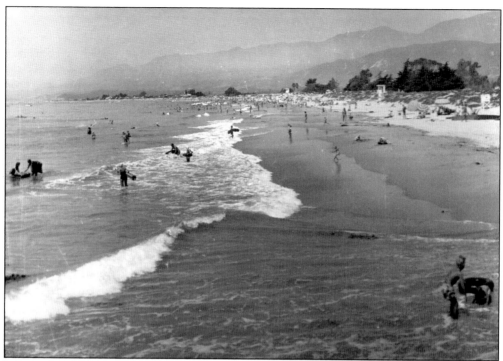

Just another day in paradise, 86 miles north of downtown Los Angeles and 12 miles east of Santa Barbara, *c.* 1945–1950. (Courtesy Lou Panizzon.)

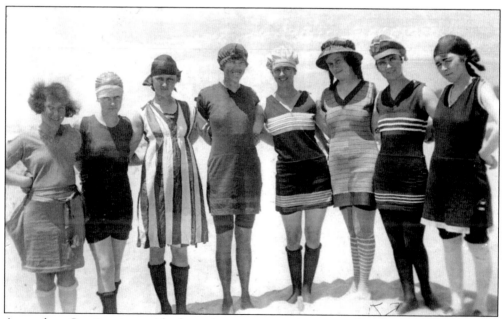

As much as Carpinterians pride themselves on not getting steamrolled by mainstream trends, these ladies were clearly on the cutting edge, sartorially speaking. They are, from left to right, Madge Crawford, Ellen Bailard, Carey Bailard, Bernice Franklin, Jean Bailard, Julia Lescher, Jessie Bailard, and Peg Pendergast, around 1920. (Courtesy Lawrence Bailard.)

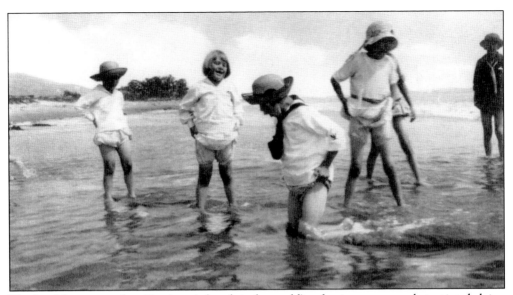

The locals' assertion that Carpinteria beach is the world's safest is not an unsubstantiated claim. The Channel Islands tend to minimize the surf on Carpinteria's beaches, while the beach itself, as shown in this c. 1930 shot of frolicking youngsters, is nearly flat, protecting bathers from deep water at the surf line. (Courtesy Carpinteria Valley Museum of History.)

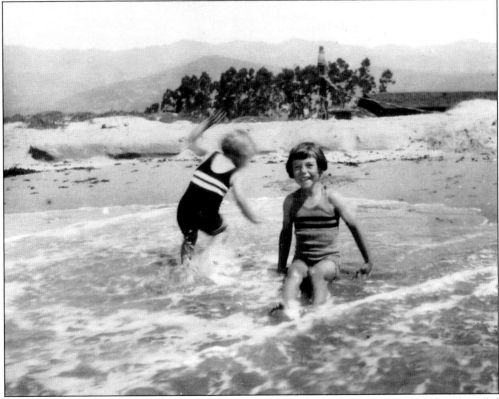

Does it really ever get any better than this? Claire Thurmond Roberts and Gloria Hamilton did not appear to think so around 1923. (Courtesy Claire Roberts.)

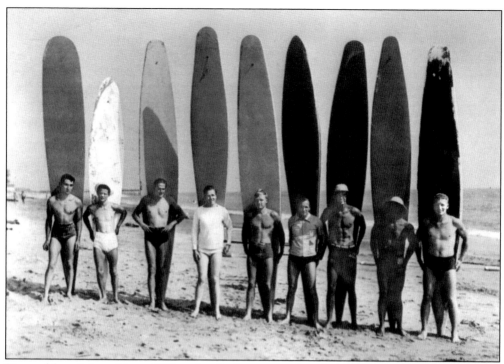

Pictured from left to right c. 1938 are Joe Rodriguez, unidentified, James Peterson, "Tud" Treloar (also known as Irving, Irwin, or Irvin, depending on the source), Phillip Bates, Robert "Red" Steward, lifeguard Myron "Mike" Sturmer, Gates Foss, and R. J. "Joe" Wulbrandt. This surfing photograph presumably was snapped moments before they jumped on their paddleboards and headed out to take on the surf at Carpinteria Beach. Based on the size of their boards, one might suspect that they were preparing to tangle with some 40-footers at Makaha. (Courtesy Martha Dowling Rodriguez.)

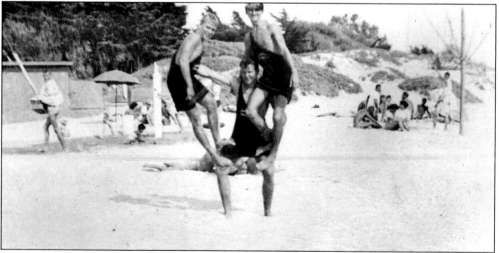

Carpinteria locals, particularly those of the adolescent variety, honed the word "cordial" to near perfection when young ladies were present on their home beach. Ernie Johnson and two friends perform the classic three-man stack, always a crowd pleaser, at the main beach in 1946. (Courtesy Ernie Johnson.)

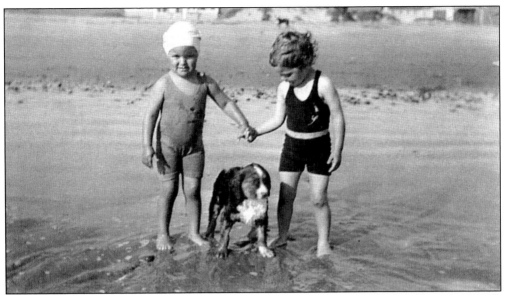

Bunny Hitchcock (left), Joan Rock, and a four-legged friend take on the World's Safest Beach with extreme caution around 1928. One can never be too careful, never mind the city fathers' mantra on safe beaches. (Courtesy Ruth D. Rock.)

An early path to the beach was across the slough on this footbridge, which began at Elm Avenue and Third Street, around 1938. Ernie Johnson remembers that the going could be precarious, as his older brother, Les, had to fish him out of the slough when he slipped off the footbridge as a youngster. (Courtesy Ernie Johnson.)

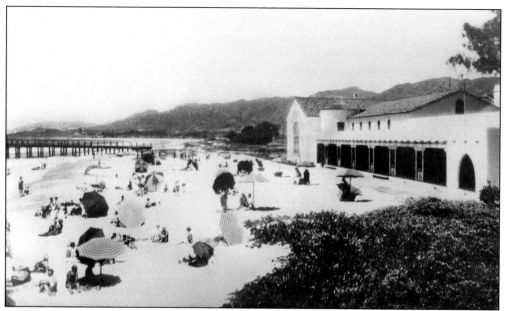

With dunes, pier, mountains, and basking beach patrons, the Cerca del Mar, seen c. 1932, anchored the ultimate beach scene. Cerca del Mar proved to be one of the more spectacular multipurpose rooms. It began its run as a posh beach-club nightspot for the elite, segued into a rehabilitation center for war-wearied soldiers returning home from the horrors of World War II, and completed its tenure as state park headquarters and a park ranger facility. (Courtesy Carpinteria Valley Museum of History.)

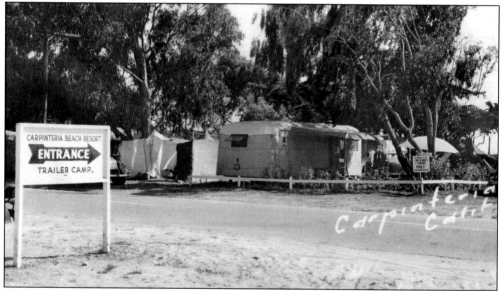

The Carpinteria Beach Resort Trailer Camp was an early relative of Carpinteria State Park. It was located at the foot of Palm Avenue. The state park took the reins in 1933, when the shoreline was designated as a state beach. "It was formally opened to the public on July 4, 1941, following the construction of campgrounds, picnic areas and parking lots by the Civilian Conservation Corps," according to a California State Park spokesperson. (Courtesy Dale Goodmanson and Raul Angulo.)

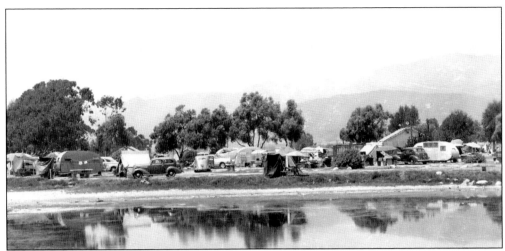

The foot of Carpinteria Creek balloons into a small lagoon mere yards before it reaches the Pacific, which is to the left in this photograph. The Carpinteria Beach Auto Camp is in the background. A careful examination of this shot will yield a fairly exhaustive overview of the day's travel trailer options. (Courtesy Sey Kinsell.)

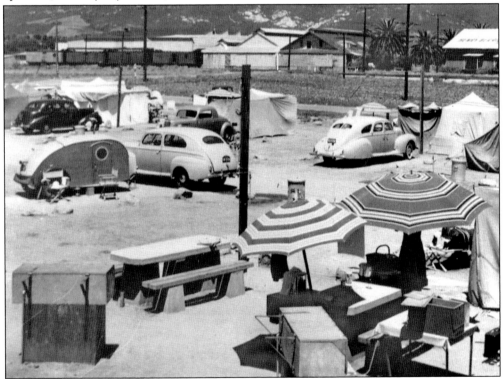

A postcard writer had this to say about the Carpinteria Beach Camp in the 1940s: "Carpinteria Beach Camp—near the 101 Highway 16 miles north of Ventura. 12 miles east of Santa Barbara at Carpinteria. Modern conveniences, Gas for cooking, Soda fountain, Bathers' dressing rooms, Excellent bathing beach, Lifeguards, Supervised playground, Fishing, Tennis, Ping-Pong, Campfire, Trailer and tent space on grass, Ocean front cabins." (Courtesy Carpinteria Valley Museum of History.)

An early view of the Jelly Bowl beach looking west toward Santa Barbara around 1928 would suggest that Carpinterians know when to leave well enough alone, as the Jelly Bowl remains largely unchanged in 2007. (Courtesy Carpinteria Valley Museum of History.)

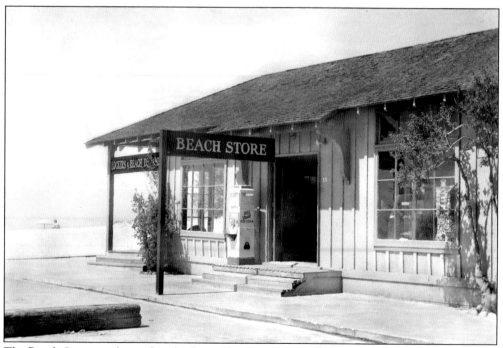

The Beach Store was located at the foot of Linden Avenue. It was stocked from floor to ceiling with addictive, delectable treats. A close look at the entrance to the store in this c. 1949 picture reveals a popcorn machine. They didn't even let customers get in the door before they started lobbying for their soda-bottle savings. (Courtesy Carpinteria Valley Museum of History.)

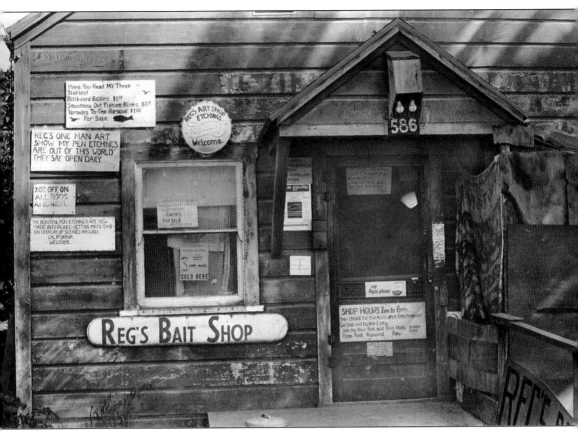

A bait shop owner who is a Renaissance man is a rare find, but Carpinteria had one. His name was Reggie Reynolds, and he ran Reg's Bait Shop on Palm Avenue, pictured here in 1969. In addition to dispensing all manner of bait, tackle, and confectionery items, Reggie also sold laminated place mats of his scenic etchings, wrote a column for the *Carpinteria Herald* on where to catch one's limit, and even shared the odd philosophical insight. The man could do it all. Anglers of all ages were encouraged to join Reg's Rod and Reel Club, Reginald Reynolds, President. Carpinteria resident Dave Moore's membership number is 38,172. (Courtesy of photographer Tom Moore.)

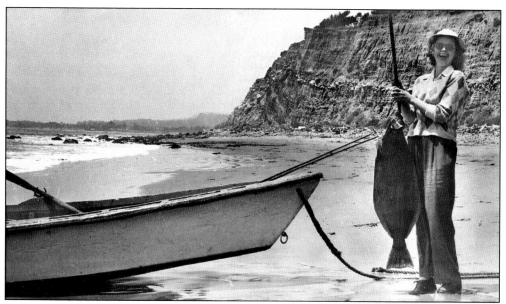

Kay Bailard landed this spectacular halibut at Loon Point in 1946. Fish stories were unnecessary in the 1940s, as the catch of the day generally spoke for itself. Fish were not the only things that were caught at Loon Point. Local authorities periodically reeled in bootleggers who favored this area as a drop-off point for their goods. Lawrence Bailard reports that, "Fast boats called rumrunners brought the illicit liquor near shore in burlap bags. The bags were off loaded into skiffs, and a skilled oarsman would row the boat through the breakers. This was quite a feat at night. The bags were carried up a trail to a waiting truck. On one occasion a truck was hijacked at the foot of Lambert Road, and two bootleggers were killed. Another location where liquor was brought ashore was at the Higgins' asphalt mine. One night a skiff turned over and the load dumped. All the sacks, less one, were retrieved. My father was fishing there the next day and found it. He was a popular man in the valley for a few days." (Courtesy Lawrence Bailard.)

A beaming Vera Bensen displays her catch at Carpinteria Pier. Cerca del Mar is in the background to the right, and a Southern Pacific freight is rumbling through just in front of the eucalyptus trees around 1950. (Courtesy Vera Bensen.)

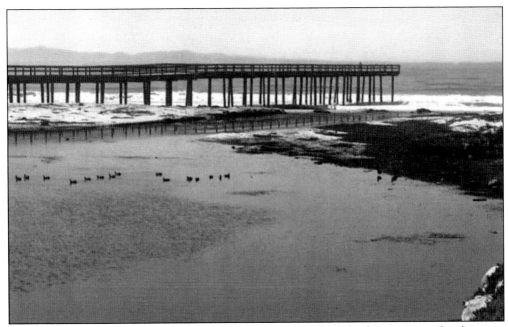

Carpinteria Pier was a fixture for decades. It stood just to the left of Carpinteria Creek as one faced the ocean. Fishing, meandering, and enjoying scenic vistas were encouraged from sunup to sundown. Shooting the pier, though certainly not a sanctioned activity, was also attempted with some regularity by numerous surfers who seemed to view it, and jumping off the pier, as a rite of passage around 1950. (Courtesy Sey Kinsell.)

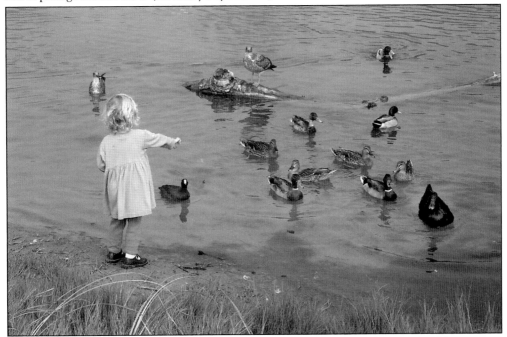

Stella Moore, pictured in 2003, feeds the ducks, coots, and seagulls at the mouth of Carpinteria Creek, adjacent to the State Beach. Visitors here often have the good fortune to see pelicans, egrets, and herons, as well. (Courtesy photographer Tom Moore.)

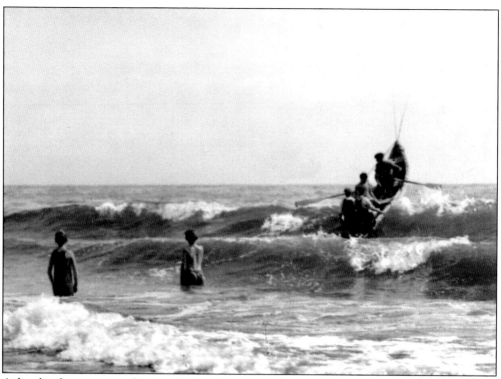

A dory heads out to sea at Carpinteria Beach in a scene that would be enacted repeatedly during the lifeguard championships that were held on this beach half a century later. (Courtesy Carpinteria Valley Museum of History, photographer Bert McLean.)

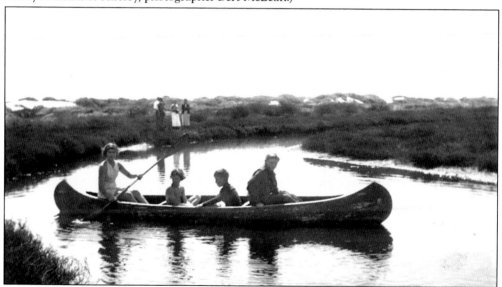

Barbara Hitchcock, paddle in hand, patrols the slough with Joan Rock and two friends around 1930. Fishing and canoeing the slough were commonplace in the first half of the last century. The Carpinteria Salt Marsh Nature Park is to the left of where this photograph was taken. Canoeing in Carpinteria was not confined to idyllic locales like the slough but was often taken out into the surf. (Courtesy Ruth D. Rock.)

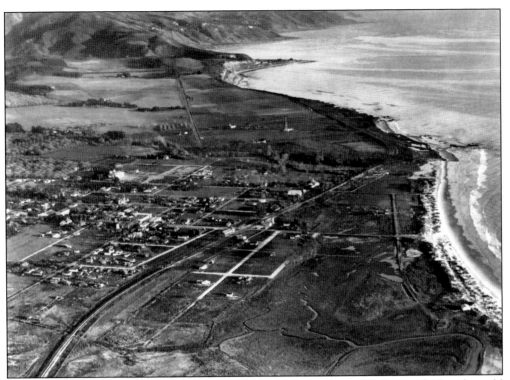

Carpinterians' early affinity for getting their horses, cars, and motorcycles on the beach could easily have been fueled by the fact that one of the first routes from Carpinteria to Ventura was on the beach at low tide. This aerial view shows the stretch of coastline that had to be negotiated prior to the completion of the Rincon Causeway in 1912. (Courtesy Jerome Summerlin.)

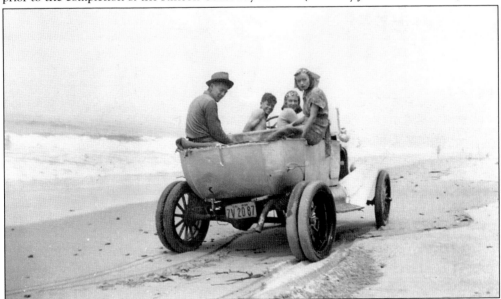

Four thrill seekers, including driver Johnny Rodriguez, are pictured at the beach in a roadster around 1930. One can only presume that they all buckled up prior to careening down the beach. (Courtesy John Rodriguez.)

Jack and Mary Rock prepare to take off on a two-wheeled tour of Carpinteria Beach c. 1926. Jack and Mary's body language seems to be hinting that Mary might have been doing the steering. (Courtesy Dale Goodmanson and Raul Angulo.)

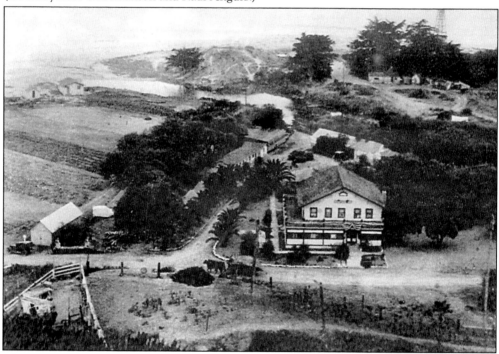

This imposing Rincon Point structure, known as the Maryland Inn, was a roadhouse with a reputation. Rumor had it that bootleg whiskey was the beverage of choice here. A wall through the middle of the house ostensibly divided the building into Ventura and Santa Barbara Counties, thus allowing patrons to scamper to the Santa Barbara side of the house when the Ventura County sheriffs arrived on the scene, a ploy customers reversed with the arrival of the Santa Barbara County sheriffs. (Courtesy Carpinteria Valley Museum of History.)

Six

Disasters and Occasional Snow Flurries

Character and resolve are often by-products of disaster. This has certainly been the case in Carpinteria.

Disasters have repeatedly tested the mettle and resiliency of Carpinterians over the years, and they have responded admirably, repeatedly. It must be something in the water. Big-hearted heroes have always shown up when Carpinteria is under duress, and not surprisingly, significant numbers of them have been firemen and policemen.

Floods in 1914, 1941, 1952, and 1969 and fires in 1917, 1964, and 1971 were among the list of disasters that left Carpinterians shaken but not broken over the decades. Heavy surf also produced some nerve-racking moments through the years. Thankfully a disastrous oil spill in 1969 has not, as of 2007, proved to be a cyclical event.

A snowstorm in 1949 provided Carpinterians with enough snow to build snowmen and toss around some snowballs, but plans for ski runs in the local foothills proved to be a bit premature.

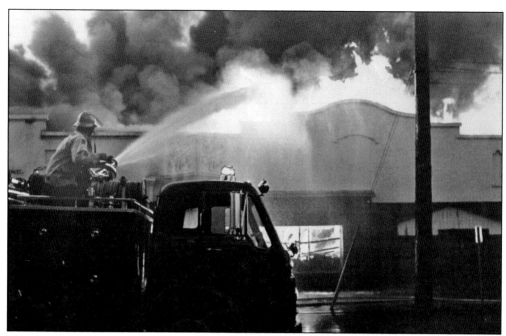

Carpinteria firemen worked feverishly to knock down the Melody Club fire of 1971 before it spread to residences in the immediate area. Disasters like this, unfortunately, appear to be part of the natural order of things. Finding personnel to respond to them, on the other hand, can sometimes be difficult. This has not been the case in Carpinteria. First-rate firefighters and policemen have always been front and center whenever disasters have struck. (Courtesy photographer Steve Malone.)

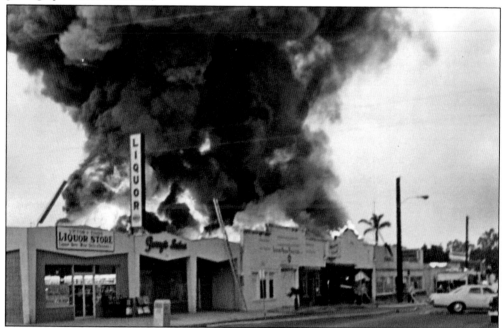

This view of the Melody Club fire in 1971 makes it clear that the whole block was in danger. Another great job by local firefighters saved the day. (Courtesy photographer Steve Malone.)

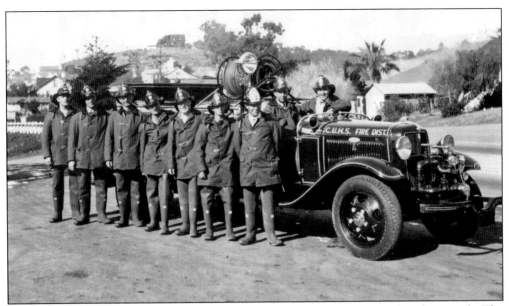

Carpinteria's first fire truck and the men who operated it are featured in this photograph. The lettering on the hood says C.U.H.S. The high school district and the fire district were one and the same on January 22, 1935. The firemen pictured are, from left to right, Max Karl, Steve Granaroli, Ted Reed Sr., Pete Granaroli, Clarence Shields, Charles Royer, Earl Gillette, Howard Irwin, and Walter Taylor. (Courtesy Carpinteria-Summerland Fire District.)

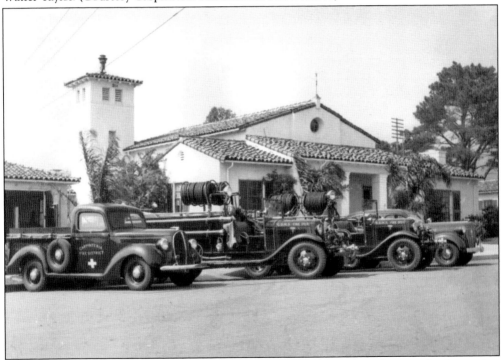

These were Carpinteria's fire-fighting vehicles as of June 1939. During this era, the fire station was located a parking lot closer to Carpinteria Avenue than it is today. (Courtesy Carpinteria-Summerland Fire District.)

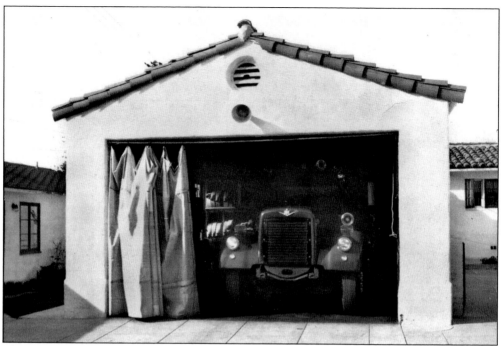

This curtained fire-engine garage on Walnut Avenue certainly must have contributed to speedy responses. (Courtesy Carpinteria-Summerland Fire District.)

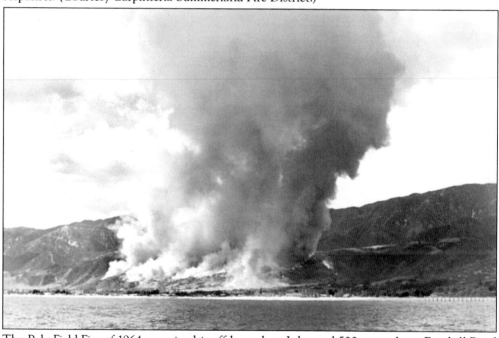

The Polo Field Fire of 1964 rages in this offshore shot. It burned 500 acres above Foothill Road from Nidever Road to Ocean Oaks before it was contained. The firestorm the Polo Field Fire created was, for all intents and purposes, a tornado of fire. A number of structures were consumed in this horrendous blaze. Surprisingly it was the tornado, and not the fire, that destroyed most of the buildings. (Courtesy Jack Risdon.)

Dick Morris, a well-respected blacksmith in the valley, was one of Carpinteria's early lawmen. He was one of a succession of constables and deputy sheriffs who kept the peace in Carpinteria prior to incorporation. Deputy Sheriff John Blackman, also known as "Blackie," is pictured here, c. 1950. (Courtesy Ernie Johnson.)

These seven gentlemen were members of the original Carpinteria police force, which was established in 1967. They are, from left to right, Fred Smith, Tom Hassenbein, John Frontado, John Carpenter, Kevin Eliason, Gil Crabbe, and Gary Tieso. (Courtesy Bill Caldwell.)

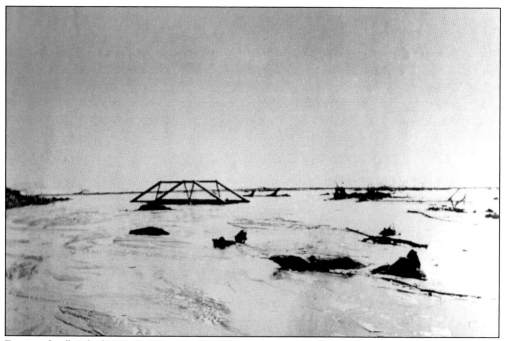

During the flood of 1914, Carpinteria Creek looked suspiciously like the mouth of the Mississippi. Although the creek has periodically been vilified for floods like this one, the Carpinteria Creek Committee has fought valiantly to preserve the creek in its natural state. (Courtesy Carpinteria Valley Museum of History.)

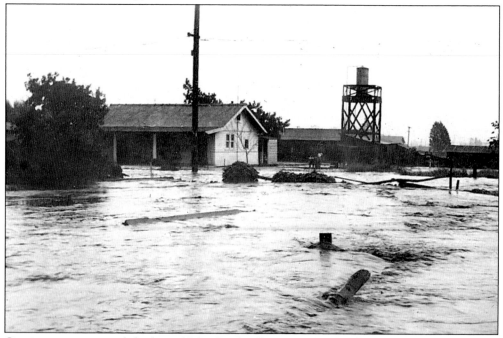

Carpinterians mourned the loss of John Rockwell in 1914. Rockwell, a mail carrier, was swept away by raging floodwaters as he steadfastly worked his rural route. The entire valley was badly battered during this flood. (Courtesy Ruth D. Rock.)

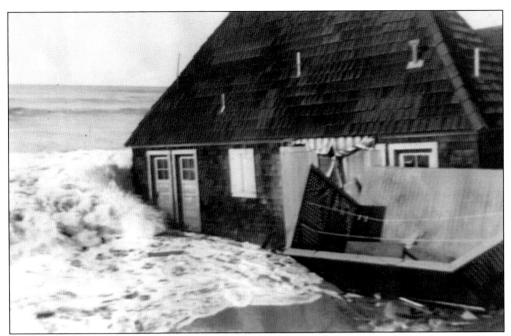

The house pictured above c. 1939 was claimed by giant surf 15 minutes after this photograph was taken. Angry Carpinterians were convinced that it was the construction of the Santa Barbara breakwater, around 1930, that led to Carpinteria's coastal woes in the ensuing decades. (Courtesy Dale Goodmanson and Raul Angulo.)

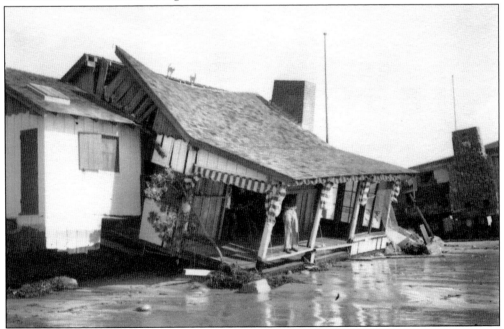

This undermined residence on the Carpinteria coastline was a casualty of heavy surf around 1940. Some of the survivors of this storm moved their Sandyland homes to inland locations they considered more secure. A number of these residences landed on Maple Avenue. (Courtesy Ruth D. Rock.)

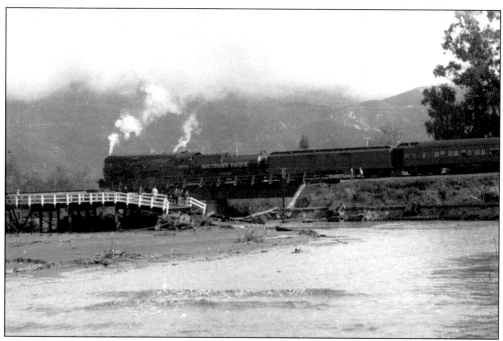

A Southern Pacific mail train awaits the go-ahead before finishing its sprint across the bridge at Carpinteria Creek during the flood of 1952. Note the partially downed bridge in the park. (Courtesy Jack Risdon.)

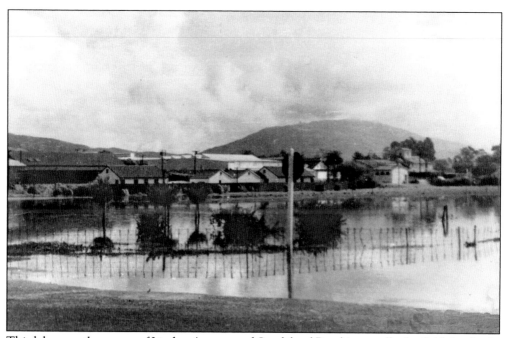

This lake near the corner of Linden Avenue and Sandyland Road is actually the field that backs up to the camper park in 1952. (Courtesy Carpinteria Valley Museum of History.)

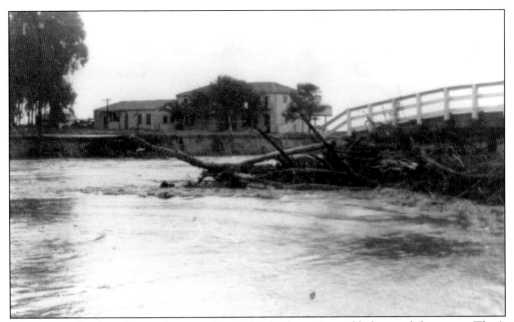

Carpinteria Creek took out a huge section of this bridge as it rumbled toward the ocean. That's Cerca del Mar looking on in the background during the flood of 1952. (Courtesy Carpinteria Valley Museum of History.)

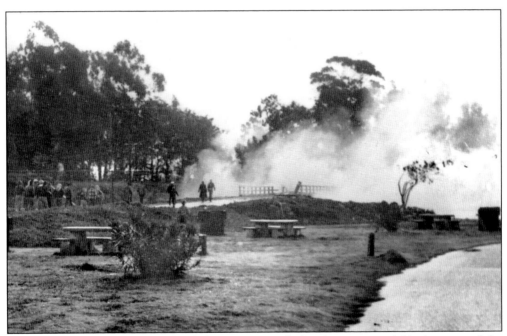

Dynamiting a bridge at the beach, while entertaining for local youngsters, did little to curtail the flood damage in 1952. (Courtesy Carpinteria Valley Museum of History.)

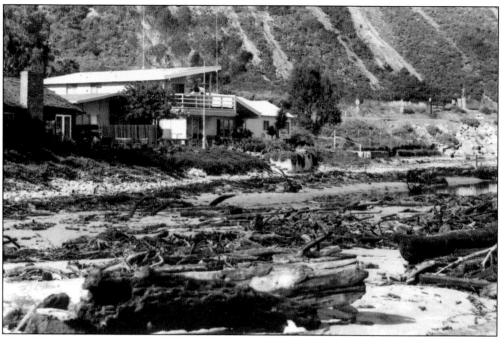

The disaster gods doubled down on Carpinteria in 1969, delivering both a flood and an oil spill. The latter, and the response to it, was the beginning of the modern-day environmental movement. This property on the Rincon was battered by both oil and flood damage. (Courtesy Carpinteria Valley Museum of History.)

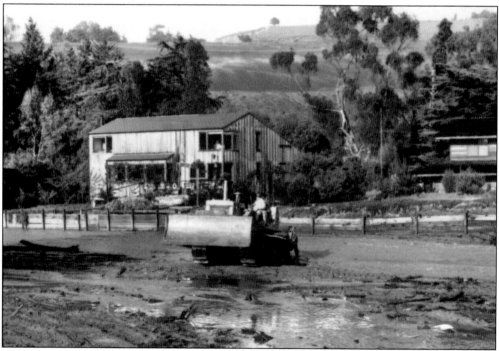

Cleanup scenes like this one at Rincon Creek were commonplace along Carpinteria's coastline in 1969. (Courtesy Carpinteria Valley Museum of History.)

John and Judy Rodriguez handled the snowstorm of 1949 like seasoned Midwestern veterans. When it snows, build a snowman; that is exactly what John and Judy did. The house behind them was one of the houses that was moved off Sandyland beach. (Courtesy John Rodriguez.)

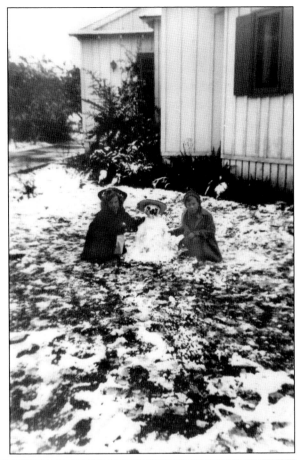

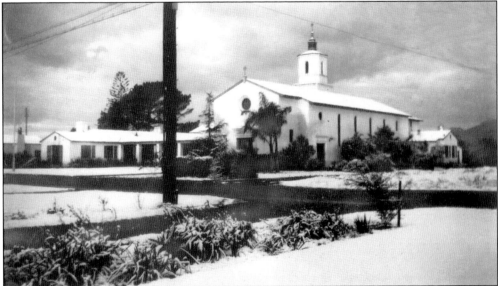

Carpinteria Community Church, having just missed a white Christmas by a nose, stands blanketed in snow in January 1949. (Courtesy Carpinteria Valley Museum of History.)

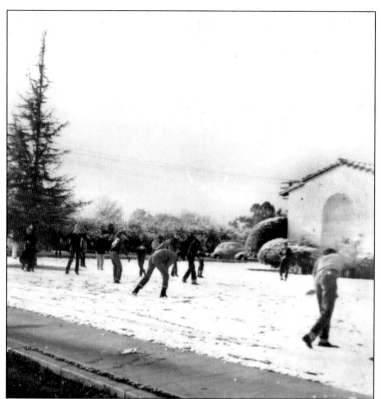

Third period was reserved for snowball fights at Carpinteria High School in 1949. (Courtesy Vera Bensen.)

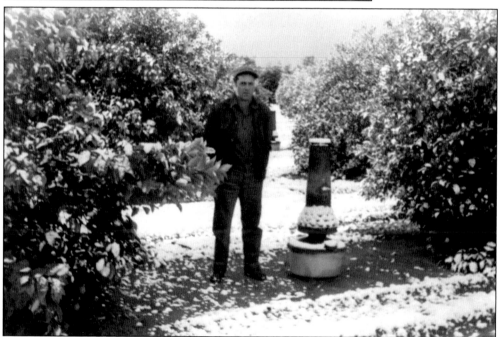

The snowfall of 1949, while largely serendipitous, was no laughing matter for the valley's farmers. Carpinteria's smudge pots all got a workout. Clair Hawley attends to one of Jack Rock's smudge pots in this picture. (Courtesy Ruth D. Rock.)

90

Seven

THE SPORTING LIFE

Carpinteria is a sportsman's paradise. Climate and geography are Carpinteria's ultimate temptresses.

Consider, for example, the routine of one of Carpinteria's early thespians. This young man's hike to school was a thinly veiled excuse for hunting, both coming and going. He clearly was not a solo act, as the school district ultimately issued a directive that required students to leave their firearms at home.

Meanwhile, at the Rincon School, more than a few youngsters whiled away their recesses and lunches fishing for steelhead trout in nearby Carpinteria Creek.

There are currently five volumes of history available on Carpinteria, and one of them is dedicated solely to football, which provides a rough approximation of that sport's stature in the valley.

Carpinteria also hosts the Russell Cup track and field meet, the oldest ongoing prep meet in California. This storied event has gained a level of prominence over the years that is generally reserved for meets that are hosted by much larger communities. Quality of performers (49 state champions and seven Olympic medalists—five gold, one silver, and one bronze), first-class organization, tradition, and world-class hospitality have all contributed to the Russell Cup's enviable run of successes.

Carpinteria's auto and motorcycle racing needs were attended to at the Thunderbowl Race Track from the mid-1940s right on into the 1960s. Races featuring men and women were standard fare during these years. Parnelli Jones, Bill Vukovich, and others of similar reputation all honed their skills at the Thunderbowl.

The multitude of sporting opportunities available in Carpinteria is nearly inexhaustible. Where, for example, can one participate in an iron man triathlon, take a world-class hike, and play polo all in the same weekend? Where, we should say, other than Carpinteria?

Carpinteria's enthusiasm for sports, as participant and spectator, remains as fervent as ever.

The creeks and canyons of the Carpinteria Valley were abundant with fish and game. In 1941, Abran Alonso and George Bliss proudly display a string of steelhead trout caught in Carpinteria Creek just south of the old Rincon School (site of present Lions Park). (Courtesy George Bliss.)

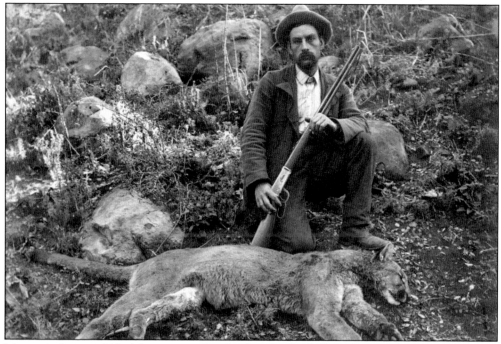

Mountain lions and black bears are still sighted in the foothills and canyons of the valley. This mountain lion was shot in Lillingston Canyon in the 1930s. (Courtesy Carpinteria Valley Museum of History.)

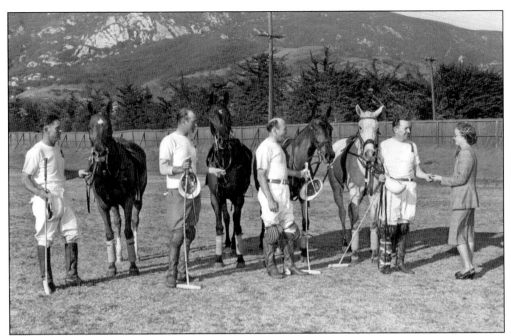

The Polo Fields in Carpinteria were developed by philanthropist Max C. Fleischmann between 1923 and 1926. He purchased the land (the Villalba Ranch) from C. D. Hubbard. Known for many years as Fleischmann's Fields, the facility is recognized as one of the finest polo venues in the United States. Many of the game's best players have demonstrated their skills on these fields. (Courtesy Joel Conway Collection.)

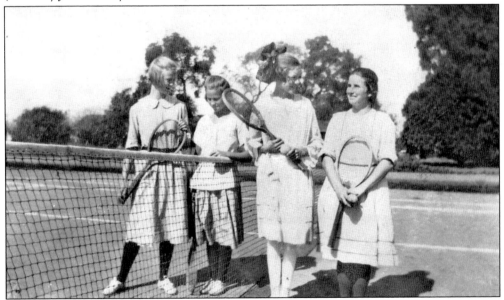

Tennis was a popular sport in the valley in the 1920s and 1930s. The Carpinteria Tennis Club was located near the present public library. Members routinely entered the world-famous Ojai Tennis Tournament. Pictured above from left to right, Faith Sheen, Ora Peterson, Lua Thurmond, and Helen Gould talk over their match in the 1920s. (Courtesy Carpinteria Valley Museum of History.)

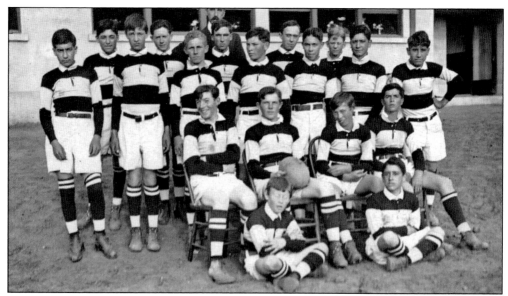

Rugby was the sport of choice before football was played at the high school. The *c.* 1914 team is, from left to right, as follows: (first row) Sheldon Martin and Albert Ayala; (second row) Lee Jeffrey, Ernest Christiansen, Jake Hales, and Larry Carrillo; (third row) Frank Alvarado, Jennings Petersen, Fred Hauser, Eddie Graham, Albert Molina, Joe Ayala, and Alfred Ayala; (fourth row) ? Hernandez, Monte Ramey, Marvin Davis, Clark Catlin, and Arthur Jorgensen; (fifth row) Principal Francis Figg-Hoblyn. (Courtesy Carpinteria Valley Museum of History.)

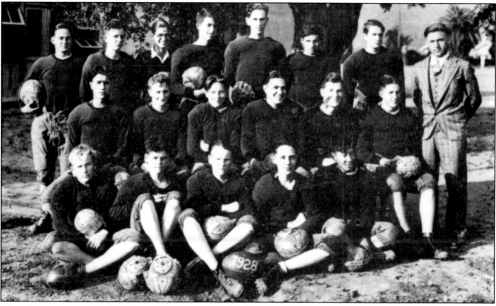

The Carpinteria High School Warriors (2-8) played their first football game on September 21, 1928. Pictured are, from left to right, the following: (first row) Fred Bates, James Brooks, Bruce Heltman, Bernard Church, and Tom Ota; (second row) Juan Cienfuegos, Frances Hebel, Richard Westcott, Charles Huber, Jack Mason, and captain Nelson Treloar; (third row) Roland Carter, Robert Stuart, manager Robert Rockwell, Marcus Cravens, Donald Barrick, Carl Westfall, Dennison Baylor, and coach William Mungar. (Courtesy Lou Panizzon.)

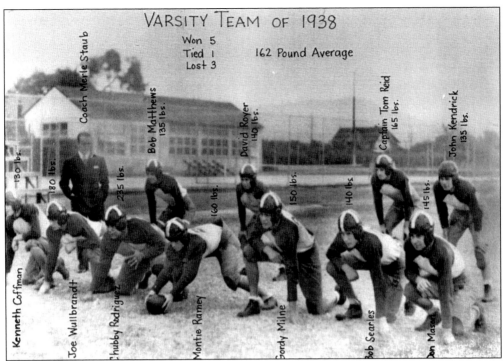

VARSITY TEAM OF 1938

Won 5
Tied 1
Lost 3

162 Pound Average

Coach Merle Staub
Bob Matthews 135 lbs.
David Royer 140 lbs.
Captain Tom Reid 165 lbs.
John Kendrick 135 lbs.
130 lbs.
180 lbs.
235 lbs.
160 lbs.
150 lbs.
140 lbs.
145 lbs.
Kenneth Coffman
Joe Wullbrandt
Chubby Rodriguez
Montie Rainey
Gordy Milne
Bob Searles
Don Mason

The 1938 Carpinteria High School Warriors were led by Most Valuable Back Phil Olds and Most Valuable Lineman Gordon Milne (team captain). Both players are members of the school's hall of fame. Merle Staub, former USC player and classmate of Frank Wykoff, coached from 1936 to 1938 (career record of 12-9-3). (Courtesy Lou Panizzon.)

Tino Fabbian (13) and Bob Latham (21) were star players on the 1947 Warrior team, coached by Frank Burrows. Fabbian became a successful Carpinteria businessman who served as the school's Booster Club president and was very active in the local Lions Club. Latham was a starting defensive tackle for Stanford when they played Illinois in the 1952 Rose Bowl. (Courtesy Lou Panizzon.)

Spotter Barney Milne (closest) assisted John Bianchin, the voice of the Warriors, as John announced home football games at Memorial Field. Both men served as presidents of the Booster Club. Active Lions Club members, they both were recognized and honored as Carpinterians of the Year. (Courtesy Lou Panizzon.)

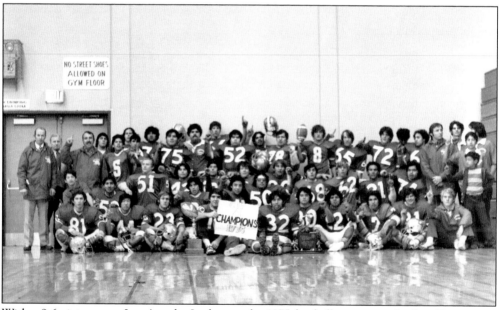

With a 9-6 victory over Los Angeles Lutheran, the 1975 football team won the first Carpinteria Interscholastic Federation (CIF) football title in school history. Led by All-CIF players Jay Canton, Doug Pauley, Rick Visueta, Walter Requejo, John Luera, and Ed Izquierdo, the team finished with a record of 11-1. Head coach Lou Panizzon was assisted by Greg Lee and Jim Bashore. (Courtesy Lou Panizzon.)

Margo Franklin, a Cal-Berkeley graduate, taught French, English, and physical education and coached girls basketball at Carpinteria High School c. 1919. (Courtesy Jane Bianchin.)

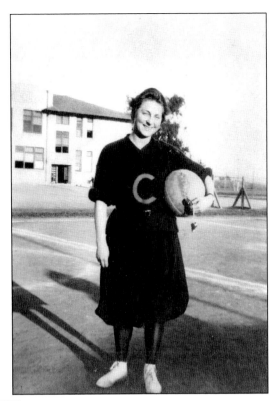

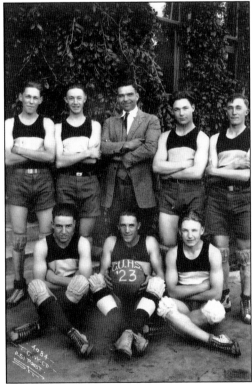

Coach Joe Fraga, who taught at Carpinteria High School for five decades (1919 to 1956), was a very popular and respected teacher and mentor. A plaque recognizing his contributions to the school and community was placed at the foot of the Memorial Field flagpole in his honor in 1957. Among his many duties, he coached the 1923 Warrior basketball team. (Courtesy Carpinteria Valley Museum of History.)

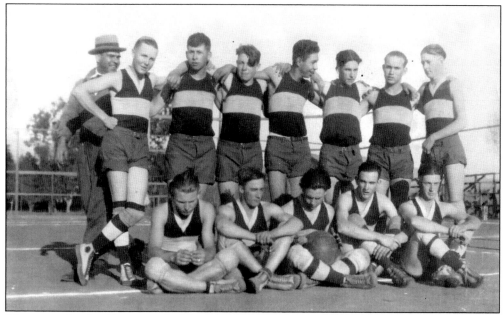

This is another Joe Fraga–coached basketball team in the mid-1920s. From left to right are the following: (first row) Robert Laurence, Melvin Treloar, Gilbert Martin, Allen Mobly, and Gordon Bailard; (second row) Coach Fraga, Harold Heltman, Tom Cravens, Alfred Thurmond, Raymond Romero, Jack Morris, Vernal Gillum, and Henry Lambert. (Courtesy Carpinteria Valley Museum of History.)

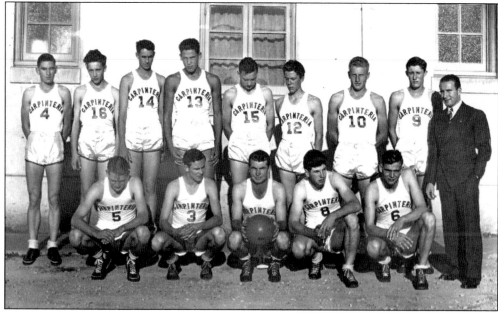

Coach Merle Staub guided the 1938 Warriors to the quarterfinals of the CIF playoffs. From left to right are (first row) Phil Olds, Kenneth Coffman, Don Mason, Tom Reid, and Gordon Milne; (second row) Neal Clark, Travis Burrell, Lawrence Bailard, Tony Rodriquez, Clarence Peterson, Wayne Johnson, Joe Wullbrandt, Bob Searls, and Coach Staub. (Courtesy Carpinteria Valley Museum of History.)

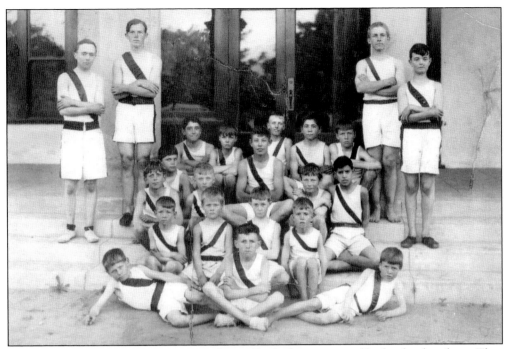

The 1914 Carpinteria track team was made up of both elementary and high school students. They participated in the second Russell Cup, which was held on Memorial Day. (Courtesy Carpinteria Valley Museum of History.)

This is the start of a sprint at the 1915 Russell Cup. The Russell Cup was started in 1913 by high school principal Francis Figg-Hoblyn. In 1914, Mr. and Mrs. Howland Shaw Russell donated a silver cup to be given to the school that won the meet three times; thus, the oldest high school track and field meet in California got its name. (Courtesy Carpinteria Valley Museum of History.)

The Russell Cup has had a long tradition of Russell Cup queens, elected by each high school class to present medals and trophies. In 1941, the queens were, from left to right, Evelyn Russell, Joan Rock, Carla Bradbury, Margaret Russell, and Marny Munn. (Courtesy Joan Rock.)

The Santa Barbara School baseball team, c. 1919, was mentored by Coach Tubbs. Santa Barbara School, now Cate School, was founded in 1910 by Curtis Wolsey Cate, a graduate of Roxbury Latin and Harvard. His vision was to establish a boarding school with the same academic excellence as the best East Coast prep schools. (Courtesy Cate School Archives.)

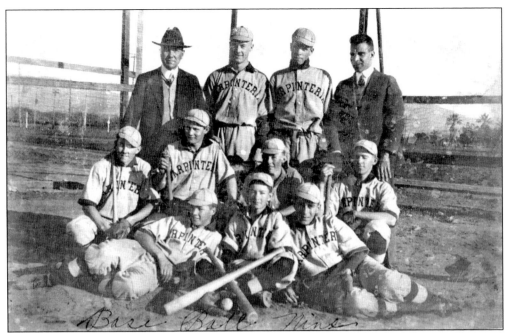

The Carpinteria High baseball team of 1925 included, from left to right, the following: (first row) Donald Bailard, Linn Linkefer, and Johnny Lobero; (second row) Harold Talmadge, Sheldon Martin, Bill Miller, and Walter Hunter; (back row) Principal H. G. Martin, Jim Deadrick, Clinton Farrar, and coach Joseph Fraga. (Courtesy Lou Panizzon.)

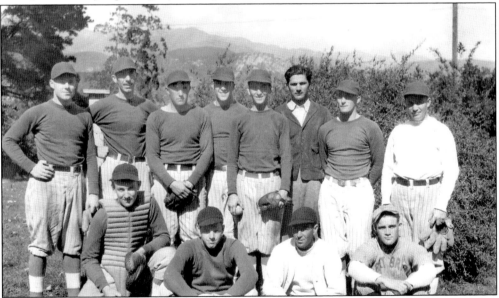

According to Cy Treloar, the Carpinteria Merchants, *c.* 1930, "Won more than they lost that year. What kind of baseball? Sort of sand lot, semi-pro, Sunday ball." The team competed in the Tri-County League. Pictured are, from left to right, the following: (first row) Harry McLaughlin, Jim "Buzz" Woods, manager Emil "Em" Stemper, and Tommy Dorman; (second row) Ray Hass, Ollie Prickett (the actor), Mix Van de Mark, Tuffy Treloar, Jim Chapman, Phil Mills, Cy Treloar, and "Carl" Carleson. (Courtesy Carpinteria Valley Museum of History.)

On May 24, 1974, the Warrior baseball team (19-5-1) became CIF champions by defeating Brethern High School 2-0. From left to right are the following: (first row) Rick Perez, Tony Burquez, John Moreno, John McWhirter, and Rudy Moreno; (second row) coach Lou Panizzon, statistician John Cerda, Bob Matsuyama, Tom Ragsdale, Kevin Gahan, Keith Bell, Bill Mitchell, Mike Jimenez, assistant coach Don Weaver, and manager Dan Regalado; (third row) Scott Kendrick, Joe Granada, Bill VanBuskirk, Chris Enlow, John Macias, and John Leighty. (Courtesy Lou Panizzon.)

Southpaw pitcher John Moreno was recognized as the CIF Single A baseball player of the year in 1974 for leading his team to the first ever CIF championship in school history. He finished with a career record of 36-9-2. (Courtesy Lou Panizzon.)

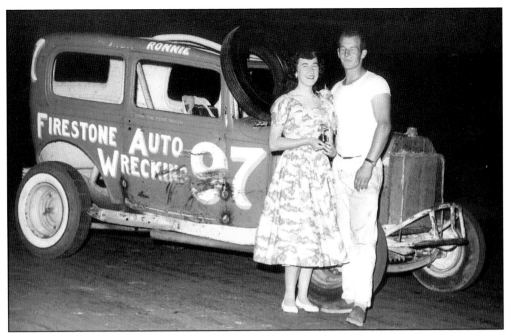

The Thunderbowl Race Track was located at the east end of Carpinteria. Midget cars, jalopies, and motorcycles dueled weekly. Drivers often paid less for their cars than they would for refreshments at a race today. Parnelli Jones and Bill Vukovich, an Indianapolis 500 winner, were two of many noted Thunderbowl drivers. Did Parnelli really think we wouldn't recognize him with his eyes closed, c. 1950? (Courtesy Lee Hammock.)

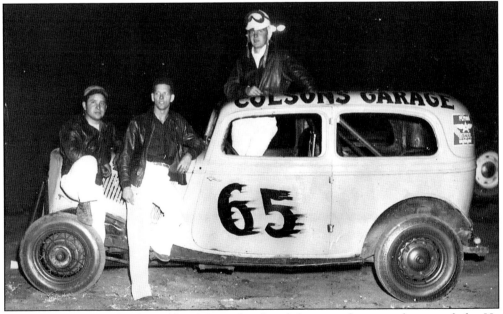

Lee Hammock, a much-admired local driver, has found the racing bug a tough one to shake. He still builds and races cars today, some 50 years after the heyday of the Thunderbowl. That's Lee standing in the jalopy advertising Frank Colson's garage. Frank is on the running board, and to his left is Joe Escareño, c. 1950. (Courtesy Lee Hammock.)

Skateboarding counts 12 million skaters in its ranks, making it America's sixth-largest participant sport. Caleb Moore, noted Carpinteria skateboarder, flies high here. Moore, who made frequent appearances in *Transworld* and *Thrasher* magazines, skated with Tony Hawk, Steve Caballero, and other skateboarding legends while growing up in Carpinteria. He gained a reputation as both a skater and designer/builder of world-class skateboarding structures. (Courtesy Kara Glenister family.)

Surfer Matt Moore is one of those rare individuals who has managed to merge vocation and avocation. The fact that he was a surfing legend certainly hasn't hurt his business at Rincon Designs. Matt was joined on local waves by every surfing icon of his era at one time or another. He is working over the Tar Pits in this photograph. (Courtesy Matt Moore.)

Eight

SCHOOLS, CHURCHES, BUNGALOWS, AND BEYOND

Tradition is a major player in Carpinteria, and nowhere is tradition stronger than in its schools and churches. When folks settle in a place for the long haul, social accountability's stock tends to skyrocket. Grocery shopping and worship services feel suspiciously like high school reunions in Carpinteria, and to some extent, they are.

Georgia Stockton's recollection in *La Carpinteria* suggests that early school consolidation efforts might have been spurred on, at least in part, by a set of encyclopedias divided between three school sites, requiring an unwieldy system of loans and returns. Near the beginning of the 20th century, the three schools joined forces, and their students began attending the newly constructed Aliso School, laying the encyclopedia conundrum to rest. The Union School, Carpinteria High School, the Tent School, Main School, and Canalino School would all follow in the ensuing years.

Methodists, Baptists, Catholics, Presbyterians, Episcopalians, and Christian Scientists all established early residencies in the Carpinteria valley, with the Methodists taking the lead in 1862.

The valley's ministers often baptized, married, and buried parishioners who rarely left their congregations for any appreciable length of time over the course of their entire lifetimes. Talk about continuity.

Architecturally, Carpinteria—like most of its Southern California neighbors—celebrated its Mediterranean climate with the building of homes that reflected various architectural styles.

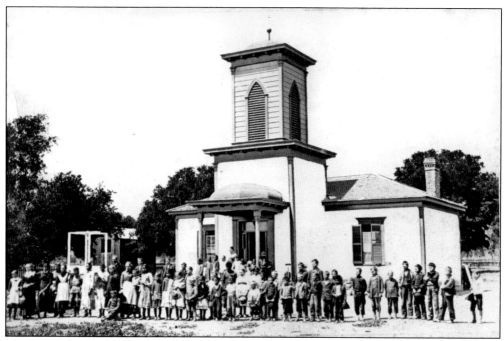

It's picture day at the Carpinteria School. It was located on the corner of Santa Monica and Upson Roads. Local families were protective of their neighborhood schools even in 1870, which would explain why the consolidation plans that were floated around the valley near the end of the century received a chilly reception. (Courtesy Carpinteria Valley Museum of History.)

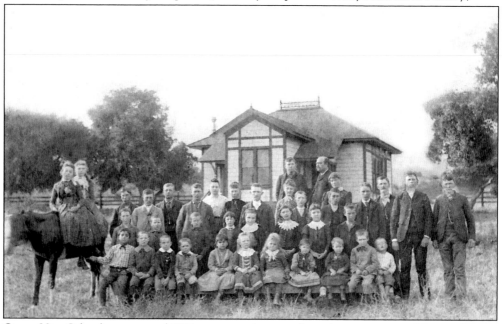

Ocean View School, seen around 1894, sat across the street from the intersection of Serena Avenue and Toro Canyon Road. This location was seriously considered as a building site for a new school at the end of the 20th century. While some students, as has been mentioned, hunted their way to school, others rode their horses. (Courtesy Harold Smith.)

That's the Rincon School peeking out from behind all that shrubbery. It was located near Carpinteria Creek right where Lions Park stands today. Legend has it that significant numbers of the school's pupils spent their recesses and lunches fishing for steelhead trout in Carpinteria Creek, which ran right along the side of the property where the school was built. (Courtesy Carpinteria Valley Museum of History.)

Around 1900, students from the Carpinteria, Ocean View, and Rincon Schools began attending the new Aliso School, located on Walnut Avenue where the Veterans' Memorial Building stands today. (Courtesy Carpinteria Valley Museum of History.)

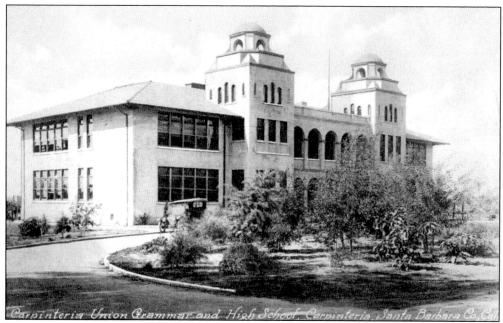

The Union School opened in 1913. It stood at the corner of today's Palm and Carpinteria Avenues. The high school was upstairs (beginning in 1914), and grammar school downstairs. Earthquake concerns closed the Union School in 1936. (Courtesy Sey Kinsell.)

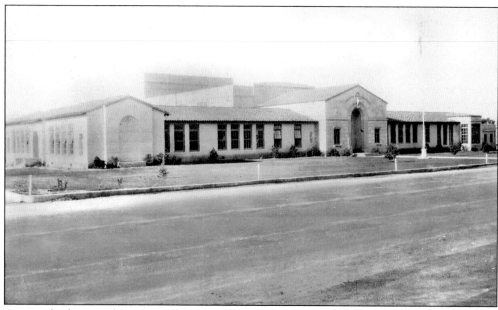

A recently christened Carpinteria High School, located on the Coast Highway at Casitas Pass Road, stands ready for action. Not long after the school was opened, c. 1930, it was identified by the *Santa Barbara News Press* as one of the best-looking buildings in the county. (Courtesy John Fritsche.)

This aerial view of the high school and environs in 1950 is primarily of interest for what is not in it—a swimming pool and a significant number of condominiums. (Courtesy Tyson Willson.)

What started out as an adventure quickly segued into a comfortless tedium. These tents on Palm Avenue housed Carpinteria students between the demolition of the Union School and the completion of the new Main School. Frank Wykoff and Mary Rystrom observe students at work in one of the tent classrooms. (Courtesy Carpinteria Valley Museum of History.)

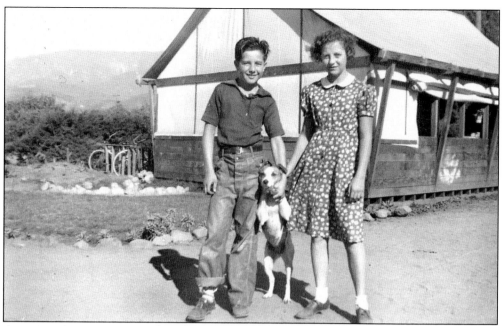

Assuming this picture was taken during school hours, the tent-school era did appear to offer some latitude on pets at school. Walter Taylor and Jane Franklin stand on either side of man's best friend. (Courtesy Joan Rock Bailard.)

Principal Frank Wykoff, with his students in pursuit, *c.* 1938, runs from the tent school to the newly opened Main School, where everyone in the picture took up residency. This front-running position was not an unfamiliar one for Wykoff, who was often referred to as the world's fastest human when he was running in the Olympic Games of 1928, 1932, and 1936. He medaled in all three Olympics. (Courtesy Carpinteria Valley Museum of History.)

This is an early view of Main School, taken from the corner of Eighth Street and Palm Avenue, with the cafeteria on the left and office to the right. Although the name on the front of this building identified it as the Carpinteria Union Elementary School right into the 1960s, it continues to be known as Main School. Its impending closure has been a tough pill to swallow for many Carpinterians. (Courtesy Sey Kinsell.)

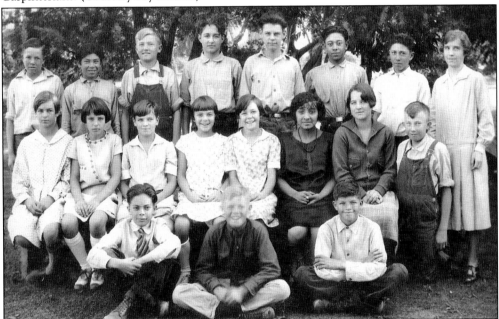

A seventh-grade class, c. 1926–1927, is pictured from left to right as follows: (first row) Charles Bliss, Howard Higgins, and John Rodriguez; (second row) Katherine Norlin, Catherine Smith, Sadie Hales, Martha Hoffman, June Coles, Roselene Velasquez, Eunice Harkey Meyers, and Kenneth Bates; (third row) Irving Treloar, Stanley Martinez, Fred Bates, Morgan Floyd, James Brooks, Triburcio Raya, Ernest Martinez, and ? Wilson. (Courtesy Carpinteria Valley Museum of History.)

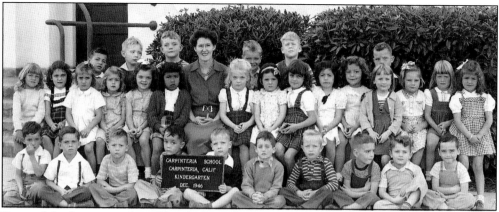

Some of the luminaries from Blanche Hamilton's 1946 kindergarten class were Lou Panizzon, Jackie Jiminez Bustillos, Matt Fabbian, Steve Boyd, Jon Washington, and Donna Peterson. The following year, these youngsters and their classmates were enrolled in one of Aliso School's first integrated classrooms, a distinction the majority of them were probably unaware of. If only the tolerant innocence of the kindergartner could be bottled for adult consumption. (Courtesy Lou Panizzon.)

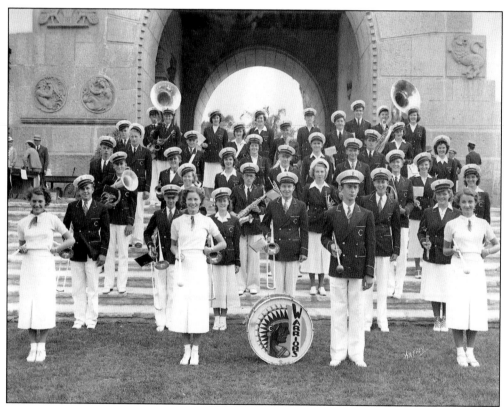

Pictured above is the Carpinteria High School Band preparing to perform at the Santa Barbara Courthouse around 1937. If this was a competition, Carpinteria wins again just based on the stylish uniforms. (Courtesy Bill Catlin.)

Cate School, initially known as the Santa Barbara School, has had a long and esteemed history in the valley. At one time, each boy was responsible for caring for one of the horses stabled at the school. This was the case in this c. 1940 photograph. (Courtesy Cate School Archives.)

The Carpinteria First Methodist South church was purchased in Santa Barbara for $600 and moved in sections to the corner of Eighth Street and Maple Avenue in Carpinteria around 1893. This move, it should be remembered, included negotiating Ortega Hill with a specially built horse-drawn wagon, which was quite a feat in itself. (Courtesy Jane Bianchin.)

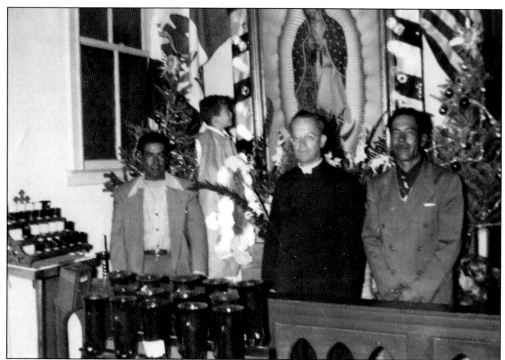

St. Joseph's Chapel, pictured c. 1950, resides on the corner of Seventh Street and Ash Avenue. Although a much larger Catholic church now exists on Linden Avenue and El Carro Lane, many locals continue to attend the chapel. The old ways are not easily set aside in Carpinteria. The chapel's stained-glass windows were donated by Santiago Campos, who had salvaged them from a church demolition in 1933. (Courtesy Alice Saragosa Vasquez.)

Carpinteria Community Church, one of builder Joe Hendy's finest efforts, is located on Vallecito Road. It has been repeatedly identified as one of the 10 most desirable locations for weddings in the greater Santa Barbara area. (Courtesy John Fritsche.)

Beginning in the early 1920s, master craftsman Joe Hendy was often the builder of choice in Carpinteria. His structures dot the valley and continue to be much admired. Hendy and his wife Miriam pose in front of the company truck in this picture, c. 1933. (Courtesy Carpinteria Valley Museum of History.)

Joe Hendy's home, c. 1925, sits near the corner of Casitas Pass and Foothill Roads. It is nestled in a lemon grove and has spectacular views of the mountains behind. If one were looking to create a citrus crate label scene that typified classic California, one needn't look any further. (Courtesy Carpinteria Valley Museum of History.)

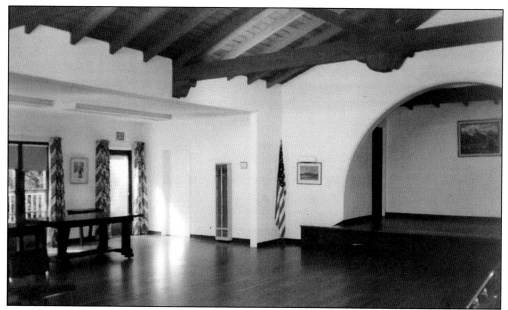

Hendy's style featured exposed beams, rounded entries, and a commingling of Spanish and Craftsman elements, all shown in this interior photograph of the Carpinteria Woman's Club. The Woman's Club was begun in 1894 as a reading club, the Shakespeare Club. Club members went on to establish the first branch library in Carpinteria in 1910. (Courtesy Carpinteria Valley Museum of History.)

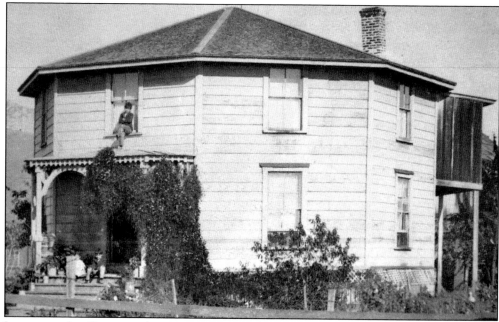

It turns out that Carpinteria's contemporary round houses had a distant relative in the valley: the Octagon House, built in 1878 by Windsor Drury and his wife, Ruth. Is there a second story exit in progress here? The Octagon House was located on the corner of Linden Avenue and Foothill Road. (Courtesy Carpinteria Valley Museum of History.)

In 1909, Jerome and Grace Chafee built Ivy Oaks, a Craftsman-style home, seen around 1920, that remains today. The most famous of subsequent owners were Chester Alan Arthur II, son of the president, and his wife, Myra Fithian Arthur, sister of Joel Remington Fithian of Rancho Monte Alegre. The present owners are Llew and Marilyn Goodfield—the Goodfield family having bought the property in 1948. (Courtesy Roxie Grant Lapidus.)

The Reverend John W. and Elizabeth Dorrance's Montgomery Ward kit-house was assembled on site at the corner of Linden Avenue and Third Street around 1925. (Courtesy Vera Bensen.)

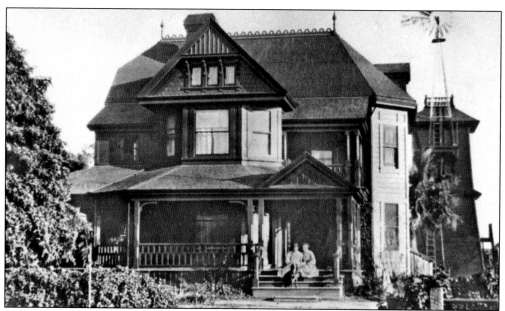

The Methodist church was not the only mobile home in early Carpinteria. Frank Hebel bought this gigantic Victorian for $850 and moved it from Maple and Carpinteria Avenues to the corner of Oak Avenue and Eighth Street. Judge Jerome Tubbs had held court in the tank house behind the Victorian when it was located on Maple and Carpinteria Avenues, a fact that is duly recorded in the *Ripley's Believe It or Not* archive. *Ripley's* described Tubbs's courtroom as the "Postage Stamp Courthouse." (Courtesy Carpinteria Valley Museum of History.)

Another residence of note was Casa Blanca, located on the beach northwest of Carpinteria. It featured, among other amenities, an indoor pool and a single-lane bowling alley, which, interestingly enough, were not generally found in the typical 1928 home. The indoor pool is pictured here. The designer of this remarkable structure was renowned architect George Washington Smith. Casa Blanca was built for Albert Isham, who, along with his celebrity acquaintances from Hollywood, honed the art of revelry to near perfection. (Courtesy Betty Zittel.)

Nine

NOTABLE PEOPLE AND PLACES

Carpinteria's notables are largely regular folks doing remarkable things. Carpinterians are well known for their generosity, compassion, savvy, and when it is called for, grit. The individuals profiled here exude these characteristics. The brief sampling of notables in this chapter, by the way, is but the tip of the proverbial iceberg. A comprehensive listing of Carpinteria's best and brightest would, without breaking a sweat, fill a volume (for example—Henry Chapman Ford, nationally renowned landscape painter; Francis F. Hebel, World War II pilot for whom the local VFW post is named; Norma Varden, character actress whose credits include *Casablanca*; Gordon Sawyer, winner of seven Oscars as sound director; Peggy Oki, acclaimed skateboarder and artist; actress Ollie Carey; and many more), but the brief assemblage of local celebrities included here are definitely some of Carpinteria's favorites.

This chapter also includes a number of well-known personalities who have spent a moment or two in Carpinteria over the decades. It would require a Paul Bunyanesque stretch to count these players on the world's stage as Carpinteria locals, but they, like all Carpinterians, have found Carpinteria to be a magnet whose attraction they just could not resist. Carpinterians applaud their good taste!

And, just for good measure, we have thrown in two notable members of Carpinteria's botanical community.

Emma Wood, a former teacher at Rincon School, was troubled by the fact that significant numbers of Carpinteria's high school graduates were unable to attend college due to lack of funds. She appointed herself a committee of one to reverse that trend, and the numerous Carpinteria youngsters who attended college through her altruism have never forgotten her generosity. It should also be noted that Emma's husband, Buddy, continued her good works anonymously even after her passing. (Courtesy Lawrence Bailard.)

Ruth Kenyon McIntyre corresponded faithfully with 14 of her soldiering classmates during World War II. Her efforts reaped huge benefits, as all 14 soldiers returned home safely. One of the 14, Roland "Rollie" McIntyre, was so enamored with Ruth that he married her. Ruth's generosity of spirit has never wavered. She remains a much-loved force in Carpinteria in her 84th year. (Courtesy McIntyre family.)

The son of Felix and Crescensia Franco, Peter Franco (Carpinteria High School class of 1937), was an outstanding track athlete who at one time held the CIF Southern Section Class B 1320-yard run record. Peter was serving on the submarine USS *Seawolf* (SS-197) when it was sunk by friendly fire by the USS *Rowell* on October 3, 1944, just north of Morotai, between the Philippine Islands and Indonesia. The crew of 102 perished. (Courtesy of Robert Franco.)

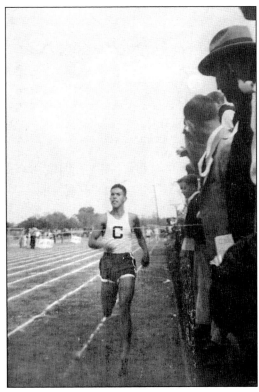

Lorenzo Martinez, pictured here in his U.S. Marine Corps uniform, spent 18 months in Korea serving his country with distinction. After returning home, he joined Joe Macias, Dominick Castellotto, and Al Tarman as a Carpinteria city mailman. Lorenzo delivered the mail and positive karma through rain, sleet, and snow—all right, maybe not snow—for 30 years. Lorenzo could easily be Dale Carnegie's point man, for a more positive individual has never walked the planet. (Courtesy Rosie Martinez.)

Oliver "Ollie" Prickett (sometimes known as Oliver Blake), a character actor who probably was most famous for playing Crowbar in Ma and Pa Kettle films, lived for many years in Carpinteria. He is credited with over 100 film roles and was the proprietor of the Alcazar Theater. Prickett enjoyed baseball and was a member of the Carpinteria Merchants team in the 1920s. (Courtesy Carpinteria Valley Museum of History.)

Lou Hoover (wife of Herbert Hoover), national president of the Girl Scouts of America, visits Vivian Rodriguez's troop in 1934. Pictured are, from left to right, Peggy Bauhaus, Joan Rock, Hoover, Joyce Miller, Bonnie Shepard, and Jane Franklin. (Courtesy Joan Rock Bailard.)

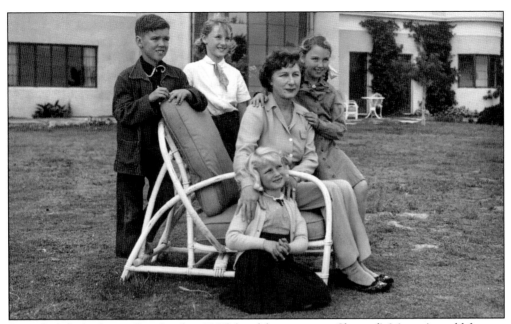

Dame Judith Anderson (knighted in 1960) lived for years near Shepard's Mesa. A world-famous actress, she was nominated for an Oscar for her role in *Rebecca* and won two Emmys for her portrayal of Lady Macbeth. She starred on the NBC soap opera *Santa Barbara* and died in Montecito at the age of 94. She is survived by several nieces and nephews, some of whom live in Carpinteria. (Courtesy Anderson Family.)

George Dangerfield looks on at a book signing for Bobby Hyde. George Dangerfield was a noted historian and author himself. For his book *The Era of Good Feelings*, Dangerfield received both the Bancroft Prize and the Pulitzer Prize in 1953. He lived on Padaro Lane with his wife, Mary Lou, and their children, Mary Jo, Hillary, and Tony. (Courtesy Tom Moore, photographer Katy Peake.)

Longtime Carpinteria resident Clifford W. Bradbury, shown here with his fellow Santa Barbara County supervisors, represented the First District for 20 years during the planning and construction of the Cachuma Water Project. He is pictured here second from the left. Bradbury was honored for his valuable work by having the dam at Lake Cachuma named for him. (Courtesy Carpinteria Valley Museum of History.)

Charles Lindbergh, the first man to fly solo across the Atlantic in the custom-built *Spirit of St. Louis*, frequently landed in the 1920s at the Carpinteria Airport (Chadbourne and Donze Airport). A true aviation pioneer, Lindbergh helped to start the airline that became TWA. Famous 1920s aviatrixes Florence "Pancho" Barnes, Evelyn "Bobbi" Trout, and Ruth Elder also used the local airport, as did Wiley Post, Howard Hughes, and Will Rogers. (Courtesy Carpinteria Valley Museum of History.)

This house on Maple Avenue, which belonged to Judge Jerome Tubbs, is where actor Charlie Chaplin married playwright Eugene O'Neill's daughter Oona. Given Chaplin's nuptial track record, the ceremony in Carpinteria wasn't exactly a singular distinction for the valley. Local neighbors, although not holding official invitations, did manage to witness the wedding through the views afforded them from the windows of their Maple Avenue homes. (Courtesy Carpinteria Valley Museum of History.)

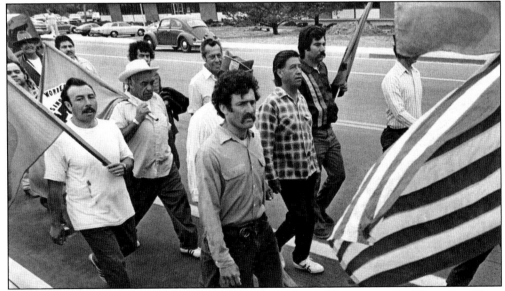

In 1972, the United Farm Workers Union president, Cesar Chavez, marched from San Diego to the capital promoting the newly enacted California Labor Relations Act. Chavez stopped in Carpinteria, speaking on the Aliso School playground with residents. He is in the checkered shirt, and to his right is Pete Relis of Carpinteria. Chavez spent the night at the Ash Street home of David and Sara Campos. (Courtesy photographer Steve Malone.)

125

Plants rarely achieve legendary status, but not so with *La Vina Grande*, Carpinteria's renowned grapevine. It is tough to ignore something that covers a half an acre and produces 10 tons of grapes annually. The folks in Chicago were duly impressed. They tried to buy *La Vina Grande* for the Chicago World's Fair. Planted in 1842, it was located on a site that is just off the intersection of Via Real and Santa Monica Road. (Courtesy Dave and Louise Moore.)

This is the Wardholme Torrey Pine as a youngster, a very lonely youngster, as the businesses which would abut the tree's acreage were only a glimmer in someone's eye at this point. This pine, which has achieved historic status as the largest tree of its kind in existence, was planted by Judge W. Thomas Ward in 1888. The seedling was found on Santa Rosa Island. The tree (Historical Landmark No. 1–City of Carpinteria) stands on Carpinteria Avenue across from the library. (Courtesy Sey Kinsell.)

BIBLIOGRAPHY

Alexander, Helen Moore. "Notes About Early Days in Carpinteria." *Noticias* Volume 28, no. 1 (Spring 1982), pp. 5–18. Santa Barbara Historical Society.

Brands, H. W. *The Age of Gold: The California Gold Rush and the New American Dream.* New York: Anchor Books, 2002.

Brown, Henry M. "Benjamin Davies Moore." *Noticias.* Volume 28, no. 1 (Spring 1982), pp. 7–14. Santa Barbara Historical Society.

Caldwell, Jayne C. *Carpinteria As It Was.* Carpinteria: Carpinteria Valley Historical Society, 1979.

Caldwell, Jayne C. *More About Carpinteria As It Was.* Carpinteria: Papillon Press, 1982.

California State Parks. *Carpinteria State Beach* pamphlet. 2005.

Carpinteria Valley Association. *Carpinteria Bungalows and Distinctive Houses.* Carpinteria: Self-published, 2004.

Carpinteria Valley Historical Society's Museum of History's Archives and Research Library.

Carpinteria Valley News. *1912 Chamber of Commerce Annual.* Carpinteria: Self-published, 1912.

Clark, Arthur Miller. *From Grove to Cove to Grove: A Brief History of the Carpinteria Valley, California.* Carpinteria: Self-published, 1962.

Gonzales, Jesus J. *La Promesa de Chuy.* Carpinteria: Self-published, 2002.

McCafferty, John. *Aliso School: For the Mexican Children.* Carpinteria: Self-published, 2005.

McWilliams, Carey. *North from Mexico.* New York: Greenwood Press Publishers, 1968.

Nimmer, Larry. *Carpinteria, Then and Now.* (Video) Carpinteria: City of Carpinteria and Community Sponsors, 1995.

Olivas, Olly. *Memoirs of an Aliso School Dropout.* Carpinteria: Self-published, 2003.

Panizzon, Lou. *Capinteria Warriors: 1928–1978 Football Records.* Capinteria: Self-published, 1978.

Santa Barbara Museum of Natural History. www.santabarbaramuseumofnaturalhistory.com 2007.

Stockton, Georgia. *La Carpinteria.* Carpinteria: Carpinteria Valley Historical Society, 1960.

Pitt, Leonard. *The Decline of the Californios.* Los Angeles: University of California Press, 1966.

Tompkins, Walter A. *It Happened in Old Santa Barbara.* Santa Barbara: Santa Barbara National Bank, 1976.

DISCOVER THOUSANDS OF LOCAL HISTORY BOOKS FEATURING MILLIONS OF VINTAGE IMAGES

Arcadia Publishing, the leading local history publisher in the United States, is committed to making history accessible and meaningful through publishing books that celebrate and preserve the heritage of America's people and places.

Find more books like this at
www.arcadiapublishing.com

Search for your hometown history, your old
stomping grounds, and even your favorite sports team.

Consistent with our mission to preserve history on a local level, this book was printed in South Carolina on American-made paper and manufactured entirely in the United States. Products carrying the accredited Forest Stewardship Council (FSC) label are printed on 100 percent FSC-certified paper.

MADE IN THE USA